DigitalFocus
the NEW MEDIA of PHOTOGRAPHY

edited by

KATHLEEN ZIEGLER
and
NICK GRECO

Dimensional Illustrators, Inc.
Southampton, Pennsylvania USA

HBI
Hearst Books International
New York, NY USA

First Published by
Dimensional Illustrators, Inc.
For Hearst Books International
1350 Avenue of the Americas
New York, NY 10019 USA

Distributed in the USA and Canada by
North Light Books,
an imprint of F&W Publications
1507 Dana Avenue
Cincinnati, OH 45207 USA
ISBN 0-688-15418-2

Distributed throughout the rest of the world by
Hearst Books International
1350 Avenue of the Americas
New York, NY 10019 USA
Fax: 212-261-6795
ISBN 0-688-15418-2

First Published in Germany by
NIPPAN
Nippon Shuppan Hanbai
Deutschland GmbH
Krefelder Str. 85
D-40549 Dusseldorf, Germany
0211-5048089 Telephone
0211-5049326 Fax
ISBN 3-910052-96-7

Address Direct Mail Sales to
Dimensional Illustrators, Inc.
362 2nd Street Pike/Suite 112
Southampton, PA 18966 USA
215-953-1415 *Phone*
215-953-1697 *Fax*
dimension@3DimIllus.com *Email*
http://www.3DimIllus.com *Website*

DigitalFocus: the New Media of Photography
Kathleen Ziegler, Nick Greco

Printed in Singapore

DIGITALFOCUS CREDITS

CREATIVE DIRECTOR/ASSOCIATE EDITOR
Kathleen Ziegler
Dimensional Illustrators, Inc.

EXECUTIVE EDITOR
Nick Greco
Dimensional Illustrators, Inc.

INTERIOR DESIGN, COVER DESIGN
& TYPOGRAPHY
Melissa Walter
MWdesign/Bensalem, PA
215-639-4181

COPYWRITER
Rachael Allendar

COPY CONSULTANT
Leona Mangol

Contents

INTRODUCTION

introduction

DigitalFocus

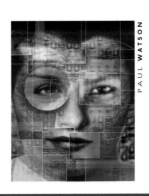

the NEW MEDIA of PHOTOGRAPHY

BOB **SCHLOWSKY**

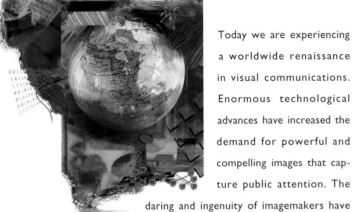

Today we are experiencing a worldwide renaissance in visual communications. Enormous technological advances have increased the demand for powerful and compelling images that capture public attention. The daring and ingenuity of imagemakers have transformed forever our understanding of the camera and the computer. The barrier that once divided photographers and digital illustrators has vanished. A door has opened on a dynamic visual universe that offers, those eager to meet the challenge, the potential and vitality of infinite design capabilities. *DigitalFocus* explores the essence of this burgeoning medium. Both explosive and impressive, the fusion of photography and digital illustration has produced a range of work that exceeds the very limits of expectation. With more than 300 full-color examples, *DigitalFocus* brings this incredible array into perspective. This premiere edition applauds the diversity of imagination and provides a detailed examination of how digital and photographic creators have combined their talents to create a new photographic genre. This powerful, new imagery transforms reality and illusion into an ever shifting metamorphic vision.

In this period of renaissance, the reciprocal exchange of conceptual and methodical acumen has afforded artists unrestrained creative license to move between the camera, the found image and the computer. Forty energetic, photo-digital professionals were invited to submit their best and most cutting-edge work. What most distinguishes this body of work is the profound differences in each of the design solutions and technical strategies. They range from painterly and surrealistic to high tech and starkly focused. Some artists rely on the cyber-palette to take the viewer on an interactive journey through cyberspace and others subtly enhance minute details. Creative techniques and software choices are also highly varied. Some photos are generated in-camera using a single application while others incorporate the manipulation and design fabrication of various programs. Each artist has developed a personal, distinct style that encompasses a spontaneous method of collage and layering, to carefully planned formats that expose a complex spatial language. To highlight the diverse nature of the industry, forty featured images take us from concept to execution. The underlying critical thinking is discussed and the software and techniques used to create the final composition are unraveled. They demonstrate the interrelationships that exist between the origin of the idea, the creative process, and the final image.

DigitalFocus presents a vibrant gallery of imagery that fully showcases the scope of work being produced that aptly demonstrates the intense influence of electronic photography on all aspects of visual communi-

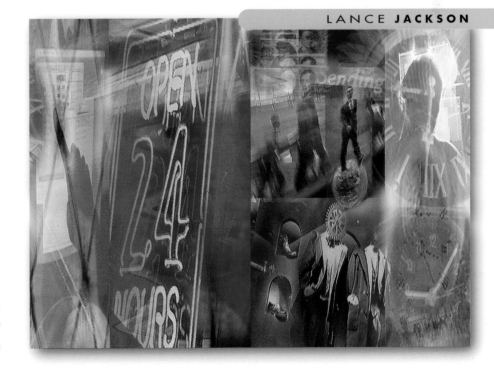

introductio

SCOTT FERGUSON

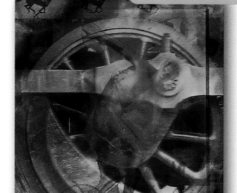

cations. Presented in nine sections, the work represents the genre of professional photo-digital images embedded with emotional expression and visual approach. The chapters -- Advertising, Business, Sports, People, Media, Editorial, Surreal, Promotional, and Experimental — expose these daring new visionaries who allow experimentation and experience to create a dynamic, visual landscape that impacts every facet of the commercial communication industry.

In the *advertising* chapter, the attention of the viewer is captured by a digital melange of provocative photos, powerful software effects and an intoxicating palette of invigorating images. Convincing advertisements, campaigns, brochures and posters are strengthened by the symbolic connotations that evoke a compelling visual language. Intimating and bold, energetic and striking, they provoke an unforgettable visual impact.

The world of *business* demands its own carefully orchestrated approach. The fast-paced, high-tech global community mandates images that reflect trends within the communication arena. Sophisticated and effectively meaningful strategies are presented with

traditional corporate themes, using a richly layered and highly textured digital palette, that give thoughtful expression to technology and worldwide cultural relations.

Full of excitement and motion, *sport* images carry the intensity of speed and the drama of competition. Exaggerated and imposing, unconstrained photographic perspective is combined with the fine-tuning capabilities of the computer to attain images that fully convey the graceful gestures and powerful attitude present in athletics. Sweeping figures of intense spirit reveal the profound impact of sports today.

Personal identities are exposed in the *people* chapter. Character emotions are portrayed through the integration of the face as a central, visual and conceptual component. Compound layering, collage and juxtaposition of elements reflect the multifaceted aspects of each individual. This eerie blending of visuals reveals layers of metaphoric meaning and encode complex messages into simple facial features.

Exploring the very boundaries of time and space, *media* looks at the most current and adventuresome design projects being developed today. Suspended in time on the printed page, the websites, CD Roms,

BARRY BLACKMAN

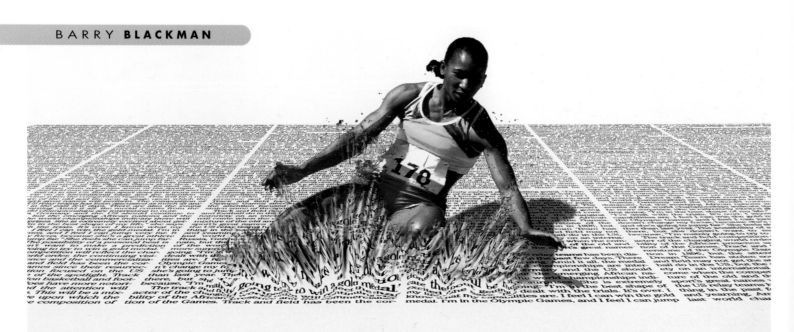

and software visuals float through the illusionary perception of space.

With the goal of accurately illustrating and illuminating, the *editorial* section gives emotional impact to the message of the adjoining text. The key is clearly defining the essential meaning and finding a visual language to implement it precise expression. Uncompromising and direct, the images link meaning and emphasize critical issues. The reader is presented with compelling visuals that embellish the editorial.

The blend of mesmerizing photography and digital drama is uncovered in the *surreal* chapter. Illusionary compositions haunt the viewer as hidden metaphoric symbols unfold. Articulate and deeply layered, obscure messages draw the viewer into a complex and subliminally unsettling world. In the surreal environment, the spectator is held captive by its hypnotic effect.

The *promotional* chapter offers the opportunity to establish a creative identity. This self representation displays both conceptual strength and a distinctive visual style. Versatile and exuberant, the images express technical capabilities while promoting confidence and a wider clientele base.

Entirely free of restraints, the *experimental* chapter offers the daring individual a dynamic set of unlimited creative tools. The inner voice finds expression as the mind and intuition are given space to explore. Personal and effective, the work reflects an extensive visual range that transform, internal visions into perceptive images.

Once a novelty, the computer is the visual illustrator's most essential creative vehicle. As we near a new millennium, the digital revolution has soared beyond all expectations. No one could have predicted the innovative and dramatic possibilities that have emerged through the fusion of photography and digital imagery. Each new technological advance has given rise to another exciting shift and a new burst of dynamic exploration. In this constantly evolving field, we offer **DigitalFocus** as a celebration of the bold vision of photographers and illustrators as they influence the future.

—Kathleen Ziegler and Nick Greco

ADVERTISING

advertising

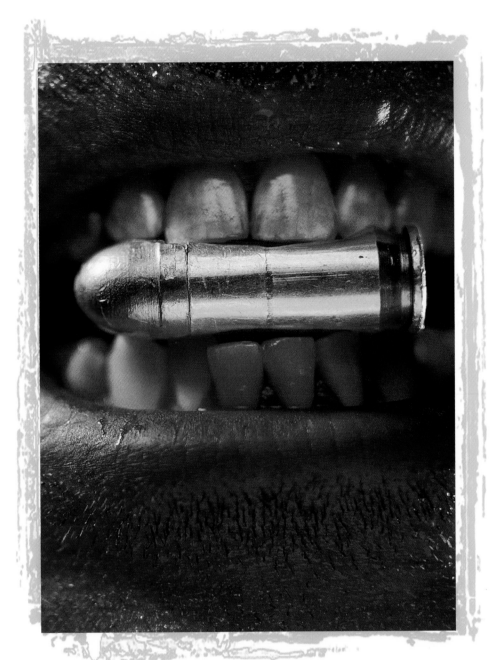

NICK
KOUDIS

AUSTRALIAN FOR ANESTHETIC

PHOTOGRAPHER
Nick Koudis

DIGITAL CREATIVE
Nick Koudis

CLIENT
Fosters Lager

SOFTWARE
Adobe Photoshop

CATEGORY
Advertisement

No subject remains ordinary when approached by Nick Koudis. This bold, arresting image was produced for an ad campaign for Fosters beer. It appeared on billboards and in print and was used as a self-promotional. Vivid and confrontational, the work relies on taut photographic qualities for its piercing visual impact and digital effects to further enhance the charged mood.

The image of the teeth biting the bullet was made in-camera and then scanned into Adobe Photoshop. The use of an extreme close-up and the tightly clenched jaw creates an underlying sense of tension. Digitally amplified color contrast and saturation heighten the focus on the bullet and gives the final photograph dynamic energy.

Blending his sharp wit with a daring vision, Koudis finds inventive and invigorating design solutions for all his projects. He integrates traditional photography and digital possibilities by concentrating on details and nuance. This subtle approach creates broad and compelling undercurrents of meaning and produces impressively memorable results.

9

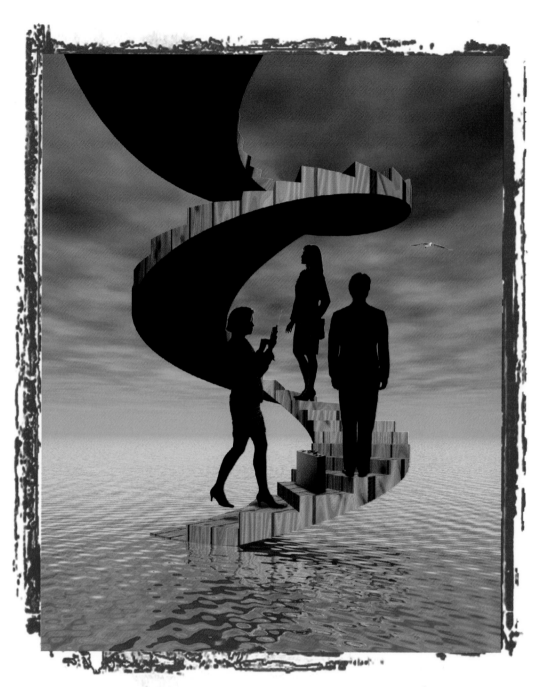

MICHAEL
WAINE

EXECUTIVES RISING

PHOTOGRAPHER
Michael Waine

DIGITAL CREATIVE
Michael Waine

CLIENT
Conceptual Stock Image

SOFTWARE
Adobe Photoshop

CATEGORY
Advertising

The corporate climb to success is cleverly presented in this illustration by Michael Waine. Rising out of the ocean, the winding staircase leads slowly upward to a hidden goal. By placing the executives near the base of the steps, it becomes clear that the ascent will not be easy. Produced as a conceptual image, this piece was created for a stock photo agency in New York known as The Stock Market.

The background, sky and stairs were rendered in KPT Bryce. These components, along with the photographic elements of the figures, were brought into Adobe Photoshop and assembled. Adjustments were implemented to the colors and shadows.

In "Executives Rising" Waine dynamically captures the essential meaning behind a familiar concept. His intriguing background helps to abstract and focus the image, while the choice of a spiral staircase emphasizes the challenge of reaching the top. His unique approach gives this illustration a refreshing originality.

ADVERTISING

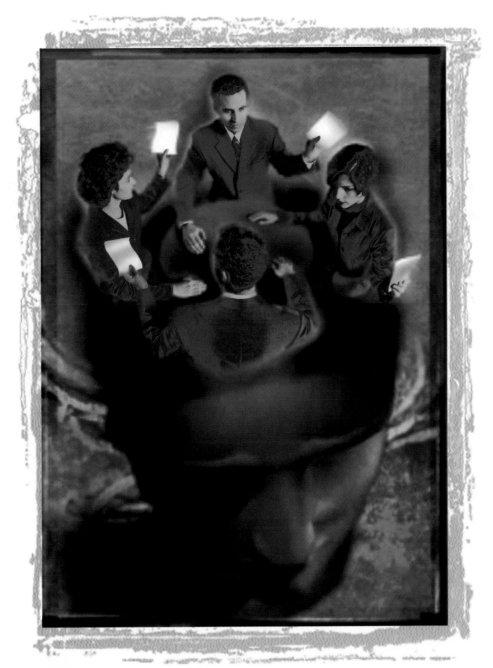

MAKE IT YOUR BUSINESS

PHOTOGRAPHER
Daniel Arsenault

DIGITAL CREATIVE
Rob Magiera

CLIENT
First Security Bank

SOFTWARE
**Adobe Photoshop,
Alias Power Animator**

CATEGORY
**Institutional / In-House
Promotional Campaign**

MAGIERA **ROB**

Created by Rob Magiera of Noumena for an in-house campaign to promote a new business expansion program for First Security Bank, this image expressively illustrates thought in action. The original concept was developed by The Hurst Group ad agency. Magiera then worked with the art director to envision a harmonious design that would be possible to create. The idea was to depict a bank client's head, superimposed with the bank divisions, working as a team.

Digital mannequins were used to establish the body positions and general layout. The four live models were posed and photographed based on this initial digital template. The 3D-statue head was generated in Alias Power Animator. The subtle textured background image was produced by scanning a sheet of rusted metal. All the elements were imported into Adobe Photoshop. Layers were created and the composition was adjusted and repositioned to form an overall balance. A rich color palette was selected and manipulated to suggest an expansive sense of illumination.

For more than ten years, Magiera has been producing elegant and engaging visual solutions for print, video and computer projects. His thoughtful response to creative challenges is even captured in the name of his studio, Noumena, a derivative of the Greek word for "think."

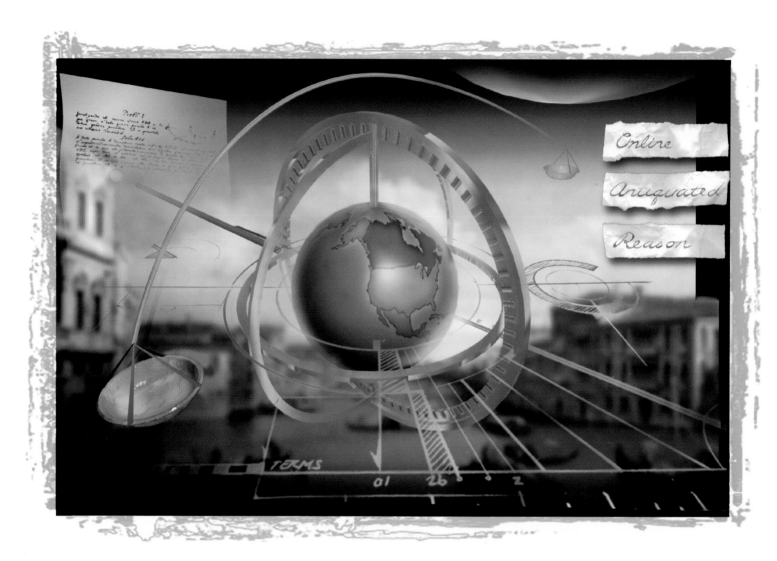

HENK DAWSON

Created to promote a conference on copyright issues, this image gracefully blends distinct visual elements as it explores a highly intellectual issue. Through symbolic language, the concern for balancing fairness and justice, where laws and attitudes are varied, is represented. In his choice of background, Henk Dawson suggests a history of Old World tradition. The long arc of the scale begins in the softly focused past, extends across the globe and tips into sharp present day contrast. This implies the far reaching, modern complexity that must be weighed in the question of copyright.

Dawson first creates a pencil sketch to determine the feasibility of his concept. Foreground elements were rendered using Form Z. The lighting and textures were added in Electric Image. Finally, Adobe Photoshop was used to assemble the completed image and modify the luminance, color and softness.

An unsaturated color palette and soft focus are signatures of Dawson's compositions. More than ten years of experience enables him to transform esoteric concepts into relevant, appealing illustration.

ANTIQUATED REASON

PHOTOGRAPHER
Henk Dawson/Stock

DIGITAL CREATIVE
Henk Dawson

CLIENT
Graphic Artists Guild,
Hewlett Packard

SOFTWARE
Form Z, Electric Image,
Adobe Photoshop

CATEGORY
Advertising

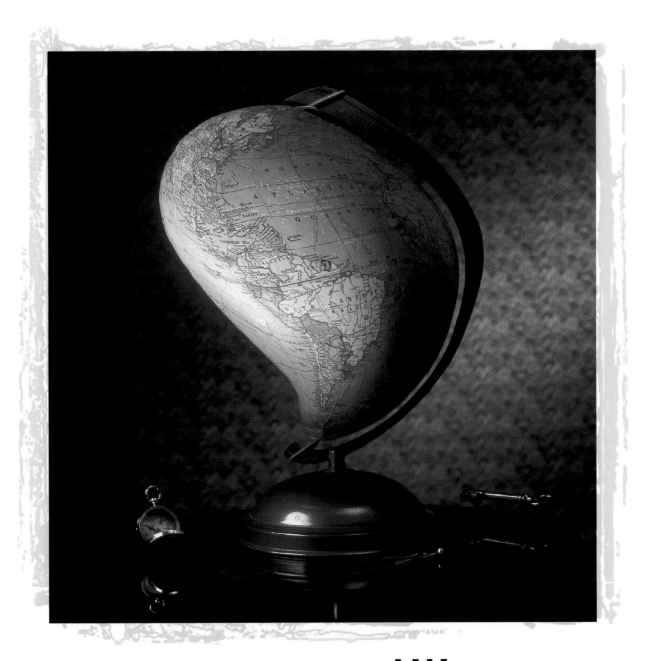

J.W. BURKEY

WARPED GLOBE

PHOTOGRAPHER
J.W. Burkey

DIGITAL CREATIVE
J.W. Burkey

ART DIRECTOR
Jonathan Rice

CLIENT
Blanks Color Imaging

SOFTWARE
Metaflow, Adobe Photoshop

CATEGORY
Advertising

J. W. Burkey was asked to create a photograph for DDB Needham's client, Blanks Color Imaging, showing the capabilities of their digital camera. His playfully surreal design solution fully utilizes the unique qualities of the product.

To demonstrate the magical tricks of levitation and object bending, Burkey relied on the camera's ability to shoot a series of exposures in perfect registration. He then repositioned and photographed the props to produce the overall image. The shape of the globe was altered using Metaflo. The final assemblage, masking and color corrections were done in Adobe Photoshop.

This filmless photographic image highlights the most recent advances in digital technology. Burkey's twelve years of experience have enabled him to balance humor and mystery. From comic to cosmic, his creative vision is on the cutting-edge.

BILL MILNE

The unique, expressive mood captured in these four panels by Bill Milne poetically carries the viewer into a magical world. These images appeared in advertisements, posters and promotional materials for the International Furniture Fair held in New York. Deceptively simple, this work balances the delicate and the dramatic through use of subtle dimensionality and theatrical lighting.

Original paper sculpture transparencies were scanned into Adobe Photoshop. The application of filters diffused the highlights and deepened the shadows creating the painterly patterns. Alterations were applied to the borders of each image to reinforce the qualities captured in the lighting. Four color separations were generated to produce fine tones, while retaining a sense of black and white.

Milne's work ranges from vibrant high-tech to the wonderfully understated image. In this impressive example, he stages a playful drama through his thoughtful use of restraint. Milne is comfortable with his ability to provide distinctive design solutions that integrate the natural world and the magic of technology.

VARIATIONS OF FURNITURE

PHOTOGRAPHER
Bill Milne

DIGITAL CREATIVE
Bill Milne

CLIENT
International Furniture Fair

SOFTWARE
Adobe Photoshop

CATEGORY
Advertising

ADVERTISING

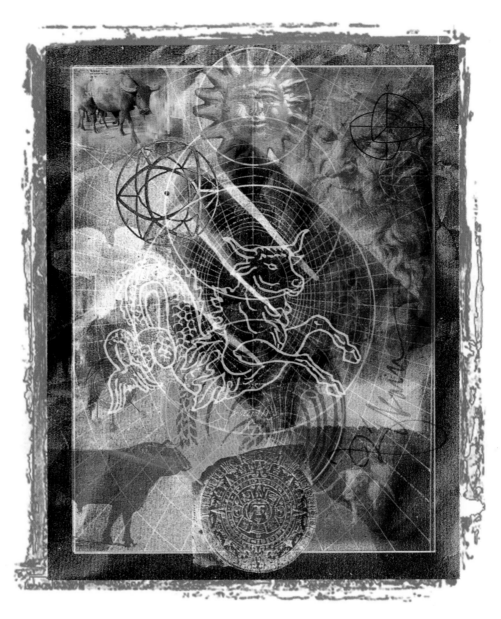

JOSEPH
KELTER

This image was originally created as an illustration for a calendar. The work focuses on Bikara, an ox who is the Guardian God of February. In this multi-layered collage, mystical symbols and delicately embedded text are blended with rich colors to suggest the relationship between Bikara and nature.

Joseph Kelter began this project by researching the images on the Internet. An initial pencil sketch was scanned into Macromedia Freehand to create the overall proportions and shape of the finished design. The Freehand file was then imported into Macromedia XRes and the masking, textures and intricate layering were added. Images selected from original photographs and stock art were assembled and revised until the proportions were correct. The feeling of depth was accomplished by varying opacity and compositing modes. Final adjustments and color corrections were completed in Adobe Photoshop.

A fine arts artist with a degree in painting and illustration, Kelter has used the electronic media since the early 80s. His flexible design approach allows him to create images where technology is submerged and concepts emerge.

BIKARA

PHOTOGRAPHER
Joseph Kelter, Various Stock Images

DIGITAL CREATIVE
BadCat Design, Inc.

CLIENT
Matsuzaki Ink, WACE

SOFTWARE
Macromedia xRes, Adobe Photoshop

CATEGORY
Advertising

15

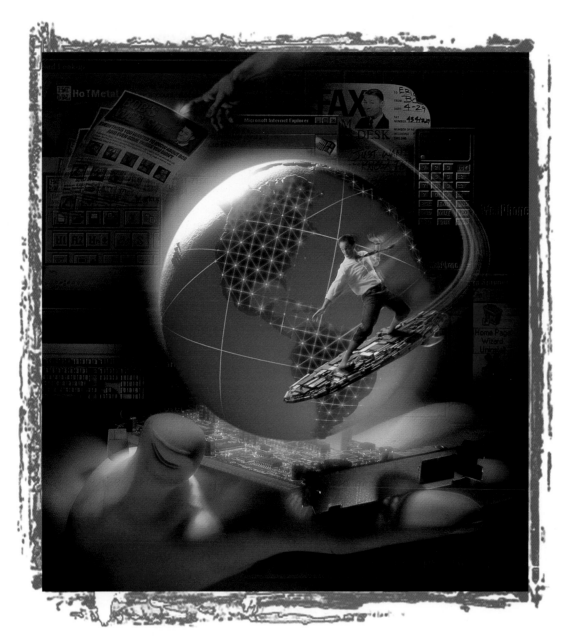

RICHARD
WAHLSTROM

WORLD SURFER

PHOTOGRAPHER
Richard Wahlstrom

DIGITAL CREATIVE
Richard Wahlstrom

CLIENT
Creative Labs

SOFTWARE
Adobe Photoshop

CATEGORY
Advertising

Richard Wahlstrom's illustration, advertising the capabilities of Creative Labs' communications card for World Wide Web surfing, depicts a balance between security and fun. The professional, pants rolled up and tie flying, leans back to enjoy a fast-paced global ride, firmly supported by a surfboard made of computer components. The serene strength of the supportive hand balances the surfer, and indicates the safe environment in which such a ride takes place.

Initially, numerous photographic elements were scanned into Adobe Photoshop. Background imagery was layered into a collage and softened with filters. The foreground items were highlighted and a blur effect was added to convey motion. A broad color palette was selected to distinguish various aspects and enhance the mood of this playful photograph.

The background elements give a clear sense of the power and capabilities of the product. They underscore and strengthen the message of potential freedom and pleasure available, when proper equipment provides support. Richard Wahlstrom's clever approach is an engaging treatment of a multifaceted subject.

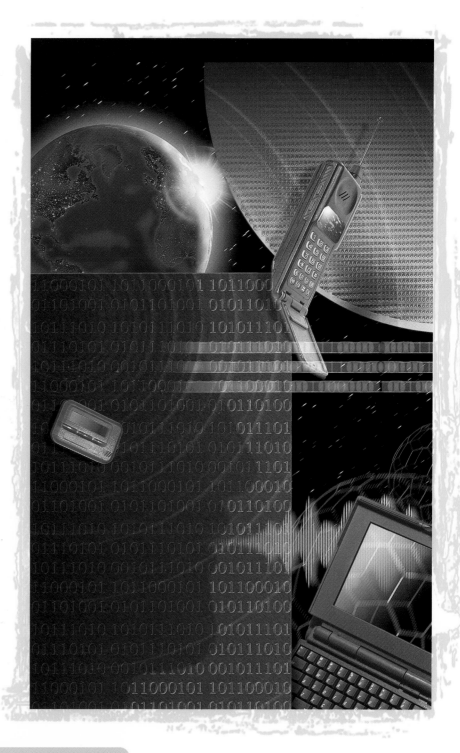

STEVEN HUNT

This crisp image presents the dynamics of modern communication, illustrating voice and data information accessibility. Through the thoughtful inclusion of essential icons, Steven Hunt explores the importance of advances in technology and the concept of global connectivity.

Hunt initially fabricated graphic elements in Adobe Illustrator. These, along with photographic components, were imported into Adobe Photoshop. Some of the elements were first masked, then assembled in layers. To provide striking emphasis, the vibrant color palette was designed using complementary hues and variations in saturation.

Through easily understood symbols, this image conveys the complex nature of message transmission. The subtle human silhouette acts to anchor the work both conceptually and formally. Radiating from the figure, words and data are projected indefinitely. Including the glowing sun and the cosmic background suggests the universal need for intercommunication. The power of Hunt's design lies in his spontaneous evolutionary approach — resulting in visually exciting imagery.

DIGITAL COMMUNICATIONS

PHOTOGRAPHER
Steven Hunt

DIGITAL CREATIVE
Steven Hunt

CLIENT
**Canadian Wireless
Communications**

SOFTWARE
Adobe Photoshop

CATEGORY
Advertising

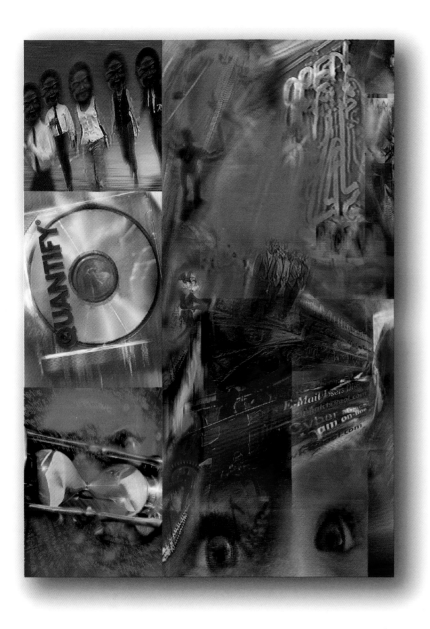

NIMS 95

PHOTOGRAPHER & VIDEO
Lance Jackson

DIGITAL CREATIVES
Clay James, Craig Ing, Laura Stoll

CLIENT
Motorola, Informix & Sunworld

SOFTWARE
Adobe Photoshop

CATEGORY
Advertising

ALT PICK 96. MADONNA IN FLIGHT

PHOTOGRAPHER & VIDEO
Lance Jackson

DIGITAL CREATIVE
Lance Jackson

CLIENT
Al Riney & Associates

SOFTWARE
Adobe Photoshop

CATEGORY
Advertising

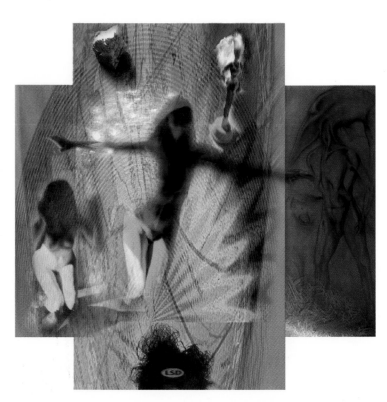

ADVERTISING *advertising*

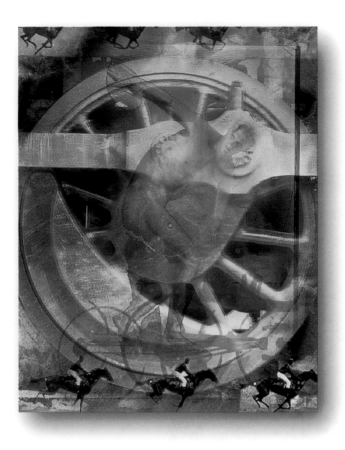

COMPETITION

PHOTOGRAPHER
Scott Ferguson

DIGITAL CREATIVE
Scott Ferguson

ART DIRECTOR
Deanna Kuhlman

CLIENT
Mead Paper Company

SOFTWARE
**Live Picture, Fractal Design's Painter,
Adobe Illustrator, Adobe Photoshop**

CATEGORY
Advertising

OPEN 24 HOURS. GEAR HEAD

PHOTOGRAPHER & VIDEO
Lance Jackson

DIGITAL CREATIVE
Christa McDonald

CLIENT
Compuserve

SOFTWARE
Adobe Photoshop

CATEGORY
Advertising Media Kit

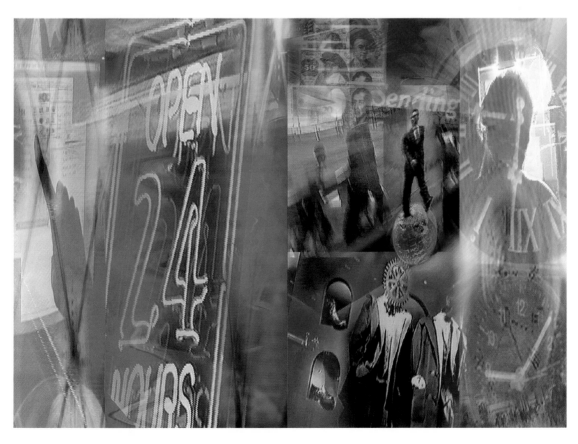

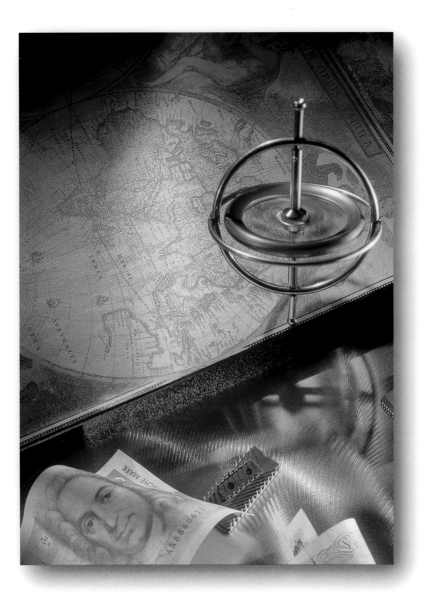

GOLD GYROSCOPE

PHOTOGRAPHER
Stan Musilek

DIGITAL CREATIVE
Stan Musilek

CLIENT
Microsoft

SOFTWARE
Live Pictures

CATEGORY
Advertising

POLAR EYEWEAR

PHOTOGRAPHER
Bill Milne

DIGITAL CREATIVE
Bill Milne

CLIENT
Younger Optics

SOFTWARE
**Adobe Photoshop,
Adobe Illustrator**

CATEGORY
Advertising

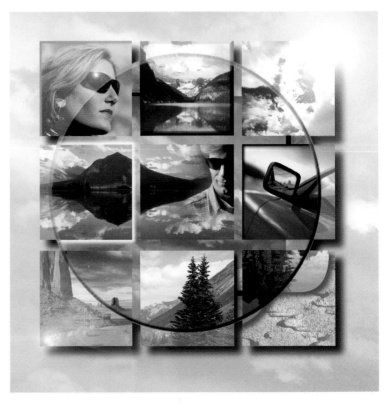

ADVERTISING *advertising*

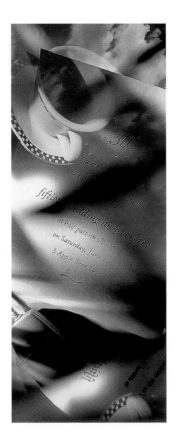
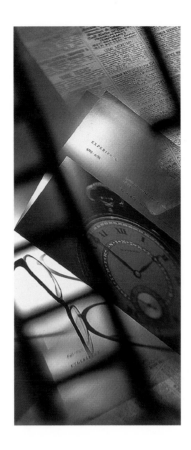

TRIPTYCH

PHOTOGRAPHER
Logan Seale

DIGITAL CREATIVES
Logan Seale, Ellen Hartshorne

CLIENT
Champion Paper

SOFTWARE
Adobe Photoshop

CATEGORY
Advertising

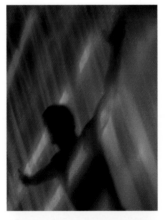

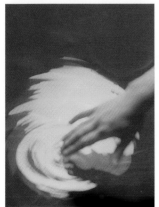
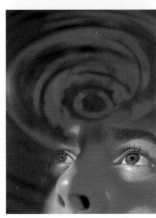

CANON SERIES

PHOTOGRAPHERS
Sharon White/Bob Packert

DIGITAL CREATIVES
Sharon White/Bob Packert

CLIENT
Canon Color Printers

SOFTWARE
Adobe Photoshop, Live Picture

CATEGORY
Advertising

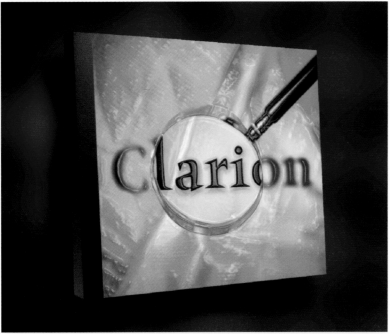

*THIS DESIGN/ILLUSTRATION WAS CREATED BY THE ARTIST WHILE WORKING AT MARCOLINA DESIGN

"CLARION"

LETRASET FONT PROMO

DIGITAL CREATIVE
Matthew Peacock*
Anonymous Productions

CLIENT
Letraset Corporation

SOFTWARE
Adobe Photoshop,
Adobe Illustrator

CATEGORY
Advertising

Diseño: Javier Romero, Madrid / New York · Producción: RAE Comunicación

RAE POSTER

DIGITAL CREATIVE
JRDG

CLIENT
RAE Publishing
Barcelona

SOFTWARE
Adobe Illustrator,
Adobe Photoshop

CATEGORY
Poster

RAE COVER

DIGITAL CREATIVE
JRDG

CLIENT
RAE Publishing / Barcelona

SOFTWARE
Adobe Illustrator

CATEGORY
Book Cover

SUN, MOON AND STARS

PHOTOGRAPHERS
Joseph Kelter, Planet Art Digital

DIGITAL CREATIVE
BadCat Design, Inc.

CLIENT
Planet Art

SOFTWARE
Specular Collage, Adobe Photoshop

CATEGORY
Advertising

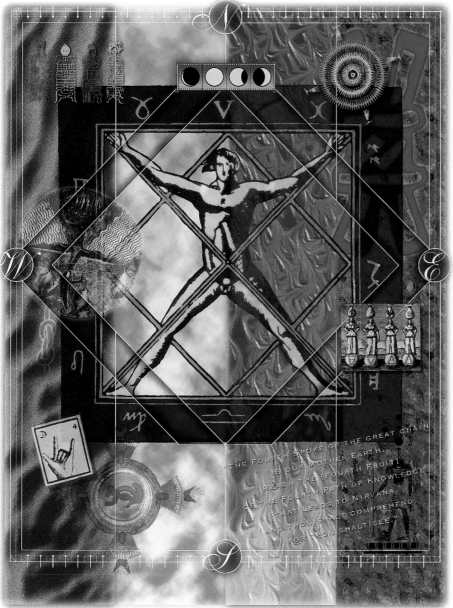

THE MATERIAL ORDER

PHOTOGRAPHER
Joeseph Kelter, Various Stock Images

DIGITAL CREATIVE
BadCat Design, Inc.

CLIENT
Specular International

SOFTWARE
Specular Collage, Adobe Photoshop, Fractal Design's Painter

CATEGORY
Advertising

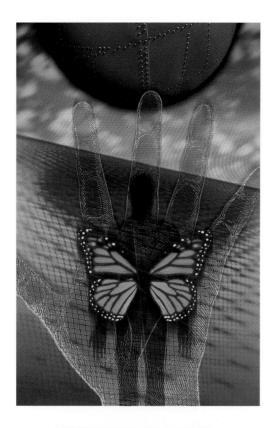

METAMORPHOSIS OF SOUL

PHOTOGRAPHER
Steven Hunt

DIGITAL CREATIVE
Steven Hunt

CLIENT
Nick Johnson Productions

SOFTWARE
Adobe Photoshop

CATEGORY
Advertising

ABSOLUT LOGO

DIGITAL CREATIVE
JRDG

CLIENT
Advertising Age Magazine

SOFTWARE
Ray Dream Designer, Alias

CATEGORY
Advertising

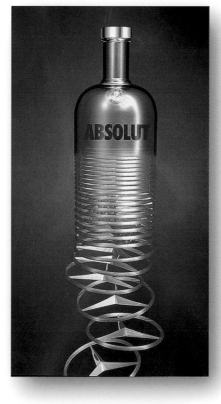

BILLBOARDS

DIGITAL CREATIVE
Philip Howe

ART DIRECTOR
Paul Matthaeus

CLIENT
GTE

SOFTWARE
Adobe Photoshop, Fractal Design's Painter

CATEGORY
Billboard Advertising

ADVERTISING *advertising*

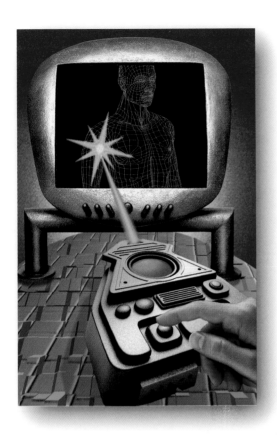

LORTAB MONITOR

PHOTOGRAPHER
Michael Waine

DIGITAL CREATIVE
Michael Waine

CLIENT
UCB Pharma, Inc.

SOFTWARE
Adobe Photoshop

CATEGORY
Advertising

THE NET

PHOTOGRAPHER
Michael Waine

DIGITAL CREATIVE
Michael Waine

CLIENT
Stock Conceptual Image

SOFTWARE
Adobe Photoshop

CATEGORY
Advertising

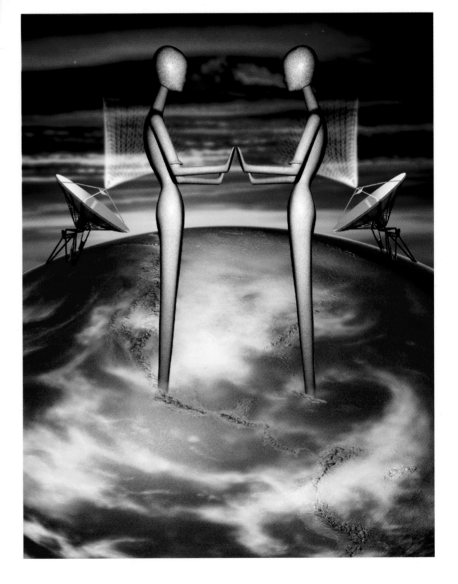

REFLECTIONS OF NAPA VALLEY

PHOTOGRAPHER
Richard Walstrom

DIGITAL CREATIVE
Richard Walstrom

CLIENT
Napa Valley Vinters Association

SOFTWARE
Adobe Photoshop

CATEGORY
Advertising

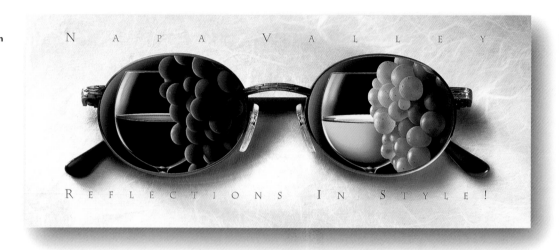

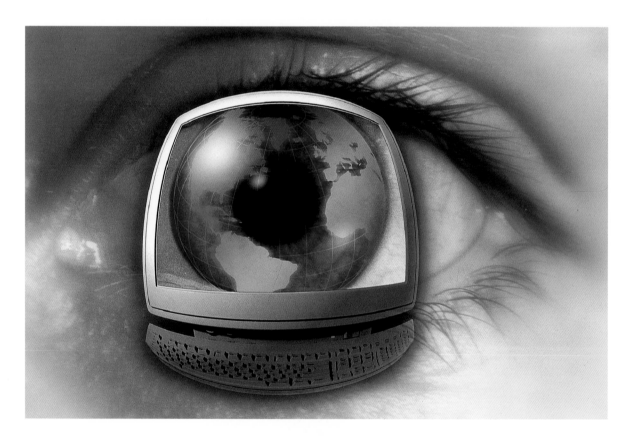

THE EYES OF THE INTERNET

PHOTOGRAPHER
Steven Hunt

DIGITAL CREATIVE
Steven Hunt

CLIENT
Motorola Corporation

SOFTWARE
Adobe Photoshop

CATEGORY
Advertising

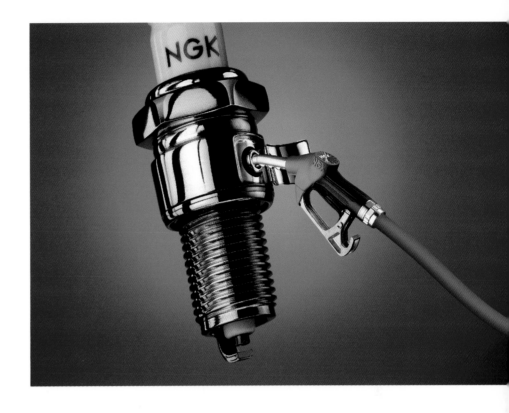

SPARK PLUG

PHOTOGRAPHER
Rick Dunn

DIGITAL CREATIVE
Rick Dunn

CLIENT
NGK U.K.

SOFTWARE
Adobe Photoshop

CATEGORY
Advertising

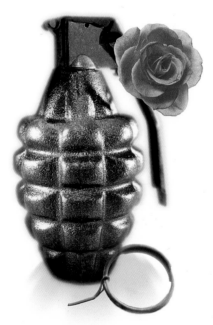

WATCH

PHOTOGRAPHER
J.W. Burkey

DIGITAL CREATIVE
J.W. Burkey

CLIENT
Spectradyne, RBMM Design

SOFTWARE
Fractal Design's Painter,
Adobe Photoshop

CATEGORY
Advertising

ART DIRECTORS
Janet Cowling,
D.C. Stipp

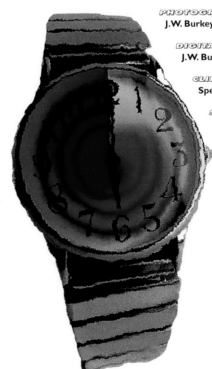

GRENADE/ROSE

PHOTOGRAPHER
Michael Waine

DIGITAL CREATIVE
Michael Waine

CLIENT
Conceptual Stock Image

SOFTWARE
Adobe Photoshop

CATEGORY
Advertising

FLOODED OFFICE

PHOTOGRAPHER
Richard Wahlstrom

DIGITAL CREATIVE
Richard Wahlstrom

CLIENT
Bell South

SOFTWARE
Adobe Photoshop

CATEGORY
Advertising

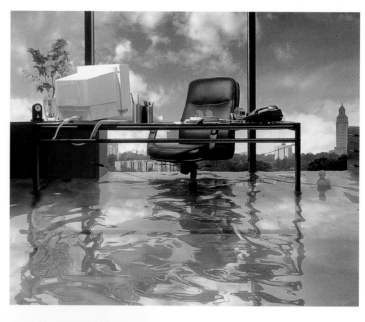

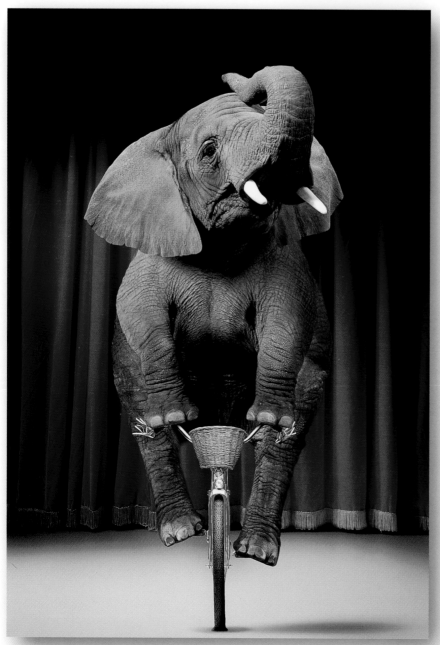

ELEPHANT ON BIKE

PHOTOGRAPHER
Richard Wahlstrom

DIGITAL CREATIVE
Richard Wahlstrom

CLIENT
Hewlett Packard

SOFTWARE
Adobe Photoshop

CATEGORY
Advertising

ADVERTISING
advertising

AMERICAN PIE

PHOTOGRAPHER
Michael Waine

DIGITAL CREATIVE
Michael Waine

CLIENT
Conceptual Stock Image

SOFTWARE
Adobe Photoshop

CATEGORY
Advertising

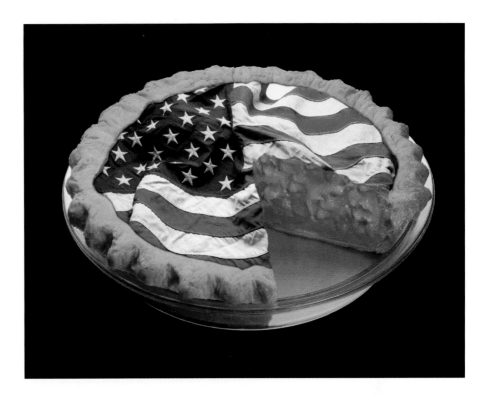

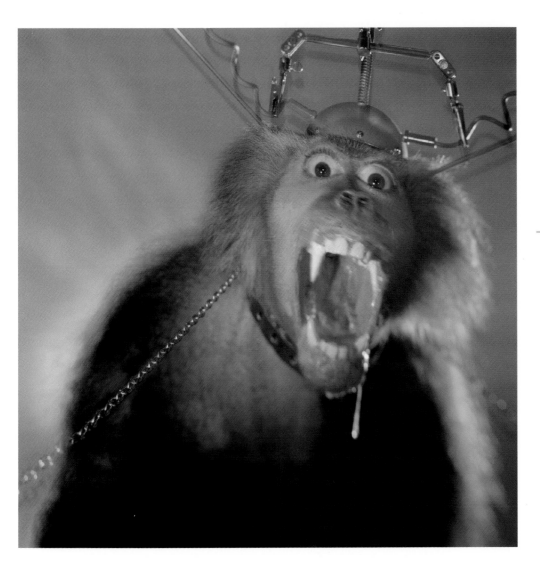

MONKEY

PHOTOGRAPHER
Nick Koudis

DIGITAL CREATIVE
Koudis Nick

CLIENT
Comedy Central

SOFTWARE
Adobe Photoshop

CATEGORY
Advertising

sports

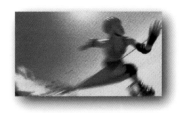

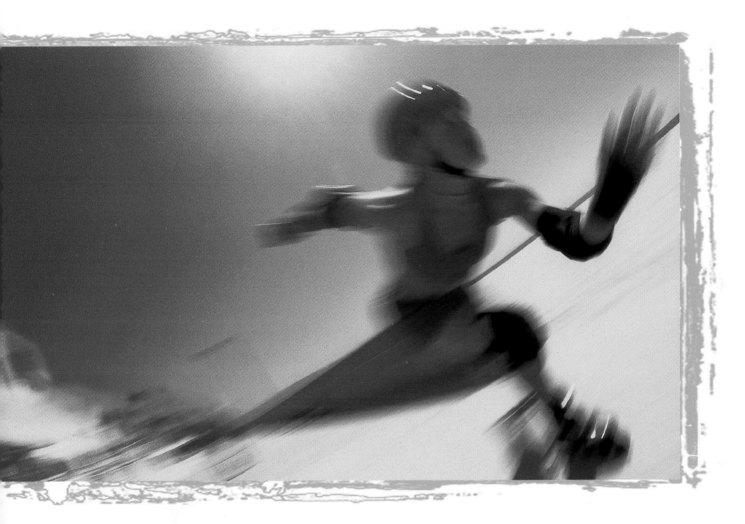

CARL SCHNEIDER

STRAND SKATER

The fast-paced world of athletic prowess is dynamically captured in this advertisement, by sports photographer, Carl Schneider. Disturbingly large and exaggeratively imposing, the skater looms past in split-second time. He wanted to portray the individuality and freedom of women athletes from an unconstrained perspective.

Using a 16mm fish-eye lens, he positioned himself within a marginal proximity of the figure. This extreme angle permitted him to distort the shape and surrounding background because he was literally feet from the subject. Shooting with a slow shutter speed, he panned the action, resulting in an intense sense of motion. Once the photo was scanned into Adobe Photoshop, it was converted from RGB to greyscale, then duotone. Next he applied his quadtone secret formula and fine-tuned the curves and tones. Selected areas were masked and final adjustments were implemented.

Schneider's photographs chronicle the extreme pace of today's athletics. His figures reveal a fresh efficiency while attaining a powerful attitude. An intense energy is coupled with graceful gestures of tireless spirit. The viewer, no longer a spectator, is captured in the suspended motion of the action.

PHOTOGRAPHER
Carl Schneider

DIGITAL CREATIVE
Carl Schneider

CLIENT
Kaiser Permanente

SOFTWARE
Adobe Photoshop

CATEGORY
Advertising

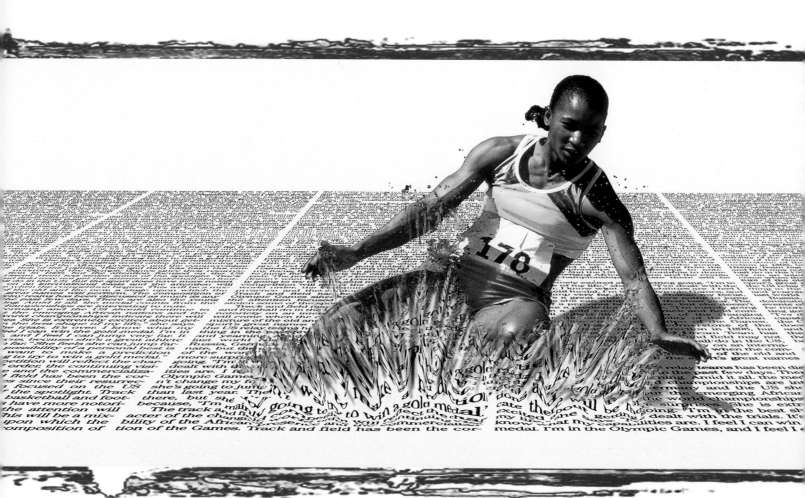

BARRY
BLACKMAN

NOBODY BRINGS YOU THE OLYMPIC GAMES LIKE THE BOSTON GLOBE

Faced with the challenge of photographically illustrating a series of advertisements to highlight The Boston Globe's coverage of the Olympiad, Barry Blackman created these exhilarating and dynamic images. The link between the plane of the newspaper page and the excitement of the action is gracefully captured in a visual strategy that allows words and athletes to interact. The readable text extends and heightens the visual message by placing it within the competitiveness of the Olympic Games.

The photographs of the athletes and newspaper were first imported into Barco Creator. Visual depth of the paper pages was achieved by altering the perspective. The waves, splashes, creases, wrinkles, and tears were then applied to the surface. Figures and text were merged together with bold shadows and a selective use of color added to the potent drama of the images.

PHOTOGRAPHER
Barry Blackman, Stock

DIGITAL CREATIVE
Barry Blackman

CLIENT
Boston Globe

SOFTWARE
Barco Creator

CATEGORY
Advertising

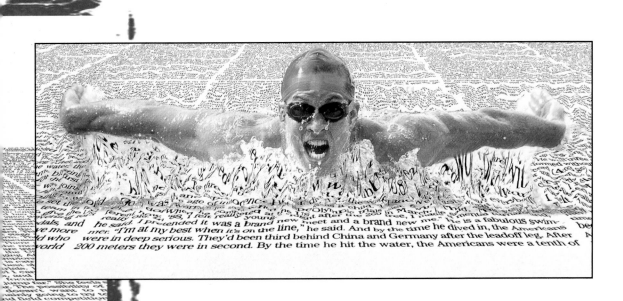

Blackman brings a sophisticated vision into these aggressive and captivating images by forming a bridge between the motion and energy of the sport and the ability of language to capture it. This successful series appeared both in print and on billboards, and shows the diversity and flexibility of an effectively rendered concept. Blackman's years of experience have lead to a powerful body of work which was recently published by Van Nostrand Reinhold in a book entitled, *Creating Digital Illusions / The Barry Blackman Portfolio.*

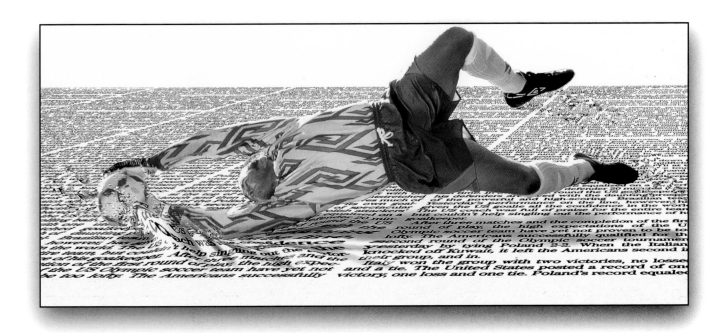

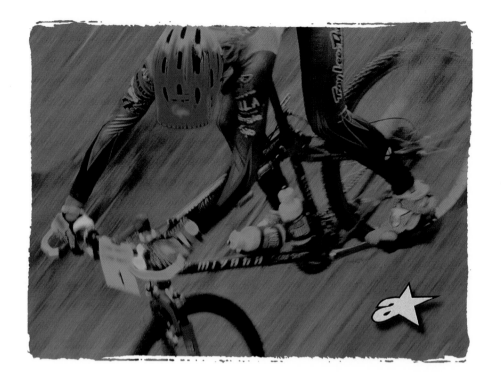

HERBOLD

PHOTOGRAPHER
Marcelo Coelho

DIGITAL CREATIVE
Caesar Lima

CLIENT
Alpinestars, Italy

SOFTWARE
Adobe Photoshop

CATEGORY
Advertising

MOTOX

PHOTOGRAPHER
Caesar Lima

DIGITAL CREATIVE
Caesar Lima

CLIENT
ONeal USA

SOFTWARE
Adobe Photoshop

CATEGORY
Advertising

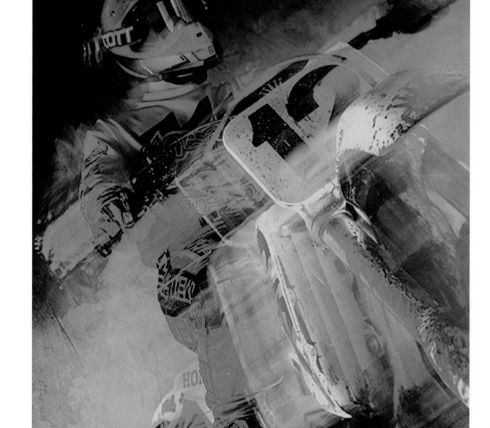

GATORADE BREAK

PHOTOGRAPHER
Carl Schneider

DIGITAL CREATIVE
Carl Schneider

CLIENT
Gatorade

SOFTWARE
Adobe Photoshop

CATEGORY
Advertising

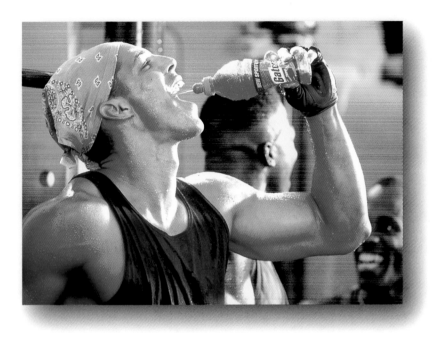

BLUR

PHOTOGRAPHER
Caesar Lima

DIGITAL CREATIVE
Caesar Lima

CLIENT
Alpinestars, Italy

SOFTWARE
Adobe Photoshop

CATEGORY
Sports

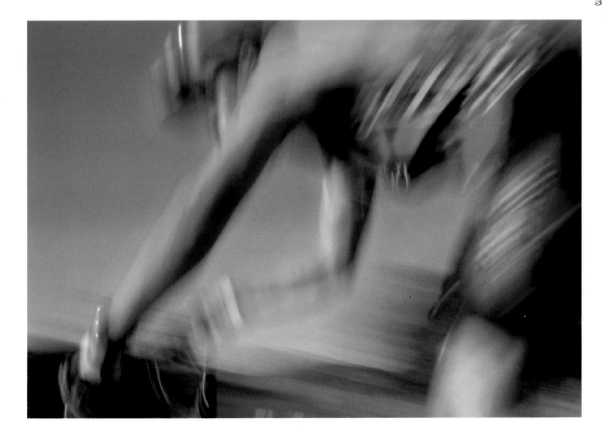

SPORTS Sports

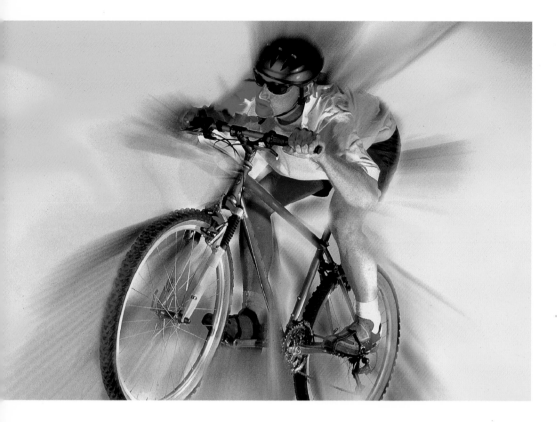

BIKE RIDER

PHOTOGRAPHER
Ken Davies

DIGITAL CREATIVE
Ken Davies

CLIENT
Masterfile Photo Library

SOFTWARE
Adobe Photoshop

CATEGORY
Sports

FAST BIKER

PHOTOGRAPHER
Caesar Lima

DIGITAL CREATIVE
Caesar Lima

CLIENT
Axion

SOFTWARE
Adobe Photoshop,
Specular Collage

CATEGORY
Advertising

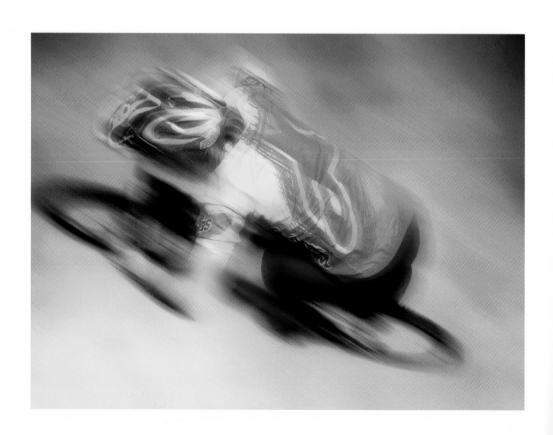

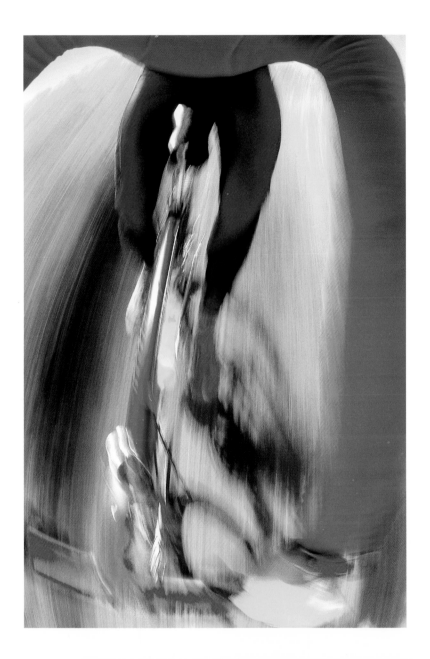

MOUNTAIN BIKER'S EYE VIEW

PHOTOGRAPHER
Carl Schneider

DIGITAL CREATIVE
Carl Schneider

CLIENT
Kaiser Permanente

SOFTWARE
Adobe Photoshop

CATEGORY
Sports

RUNNING FIGURE

PHOTOGRAPHER
Tom Collicott

DIGITAL CREATIVE
Tom Collicott

CLIENT
Adobe Magazine

SOFTWARE
Adobe Photoshop

CATEGORY
Editorial

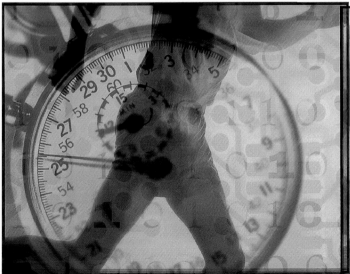

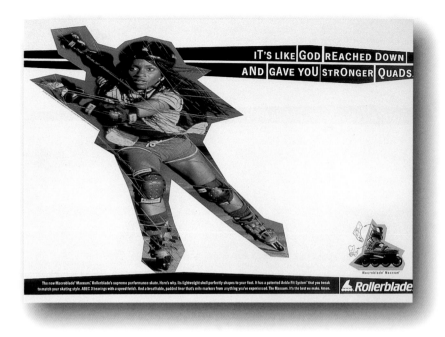

ROLLERBLADE NATIONAL AD #1

PHOTOGRAPHER
Carl Schneider

DIGITAL CREATIVE
Carl Schneider

CLIENT
Rollerblade

SOFTWARE
Adobe Photoshop

CATEGORY
Advertising

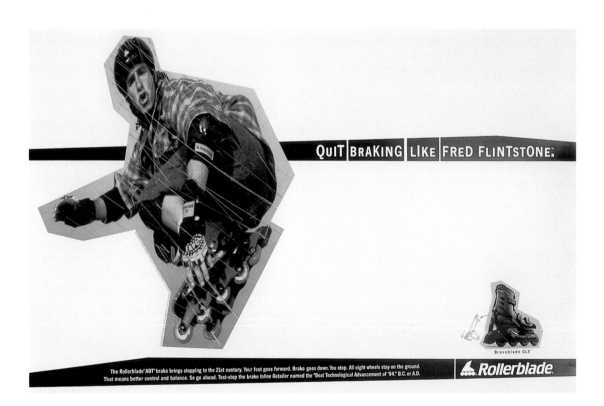

ROLLERBLADE NATIONAL AD #2

PHOTOGRAPHER
Carl Schneider

DIGITAL CREATIVE
Carl Schneider

CLIENT
Rollerblade

SOFTWARE
Adobe Photoshop

CATEGORY
Advertising

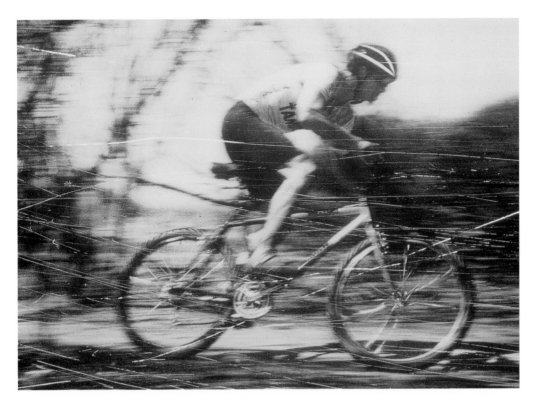

SCRATCHED MOUNTAIN BIKER

PHOTOGRAPHER
Carl Schneider

DIGITAL CREATIVE
Carl Schneider

CLIENT
Stock

SOFTWARE
Adobe Photoshop

CATEGORY
Sports

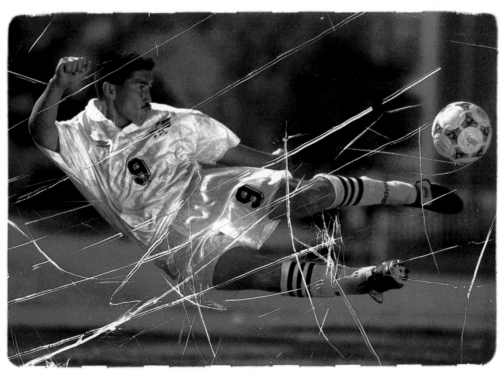

SCRATCHED SOCCER

PHOTOGRAPHER
Carl Schneider

DIGITAL CREATIVE
Carl Schneider

CLIENT
Miller Genuine Draft

SOFTWARE
Adobe Photoshop

CATEGORY
Sports

SPORTS Sports

business .BUSINESS

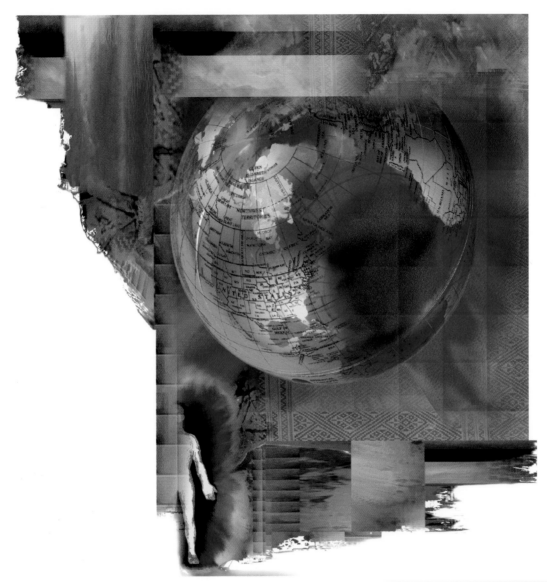

GLOBE WITH MAN

GLOBE WITH MAN

PHOTOGRAPHER
Bob Schlowsky

DIGITAL CREATIVE
Lois Schlowsky

SOFTWARE
QFX, Adobe Photoshop

CATEGORY
Stock Digital Illustration

BOB & LOIS
SCHLOWSKY

Bob and Lois Schlowsky produced this photograph for Tony Stone Images as a stock image. In this thoughtful expression of the relationship between the individual and the global community, they incorporate textural patterns from many different cultures. This richly layered and strikingly colorful piece suggests both the complexity and organic qualities of human experience.

To achieve this design, a variety of techniques was integrated and adapted from both traditional photo and digital technology. Colored gels were used to enhance the effects of the photography. Various elements were handpainted to soften the mood, and actual fabrics were scanned to acquire textures. Both QFX and Adobe Photoshop were implemented to assemble and finalize the image.

Digital technology is utilized to expand their creative options, while retaining a photographic and painterly sense. This uninhibited approach allows rough edges, textures and colors to blend with concepts to achieve a satisfying result.

41

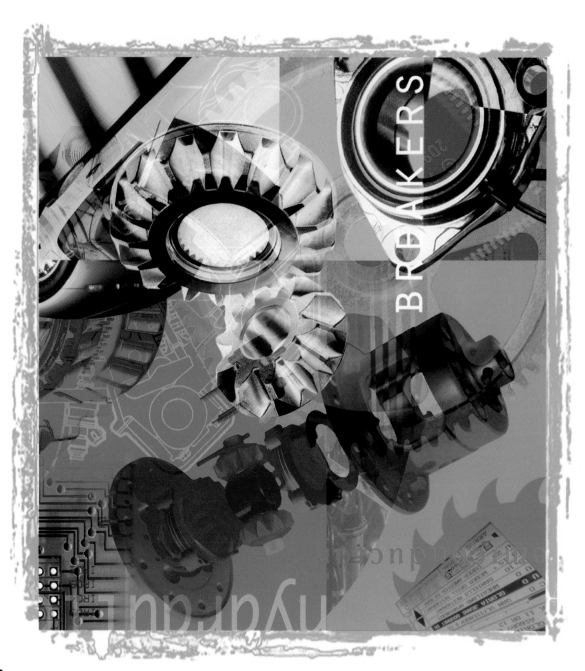

ERIC YANG

ASQC

DIGITAL CREATIVE
Eric Yang

CLIENT
Automobile Society for Quality Control

SOFTWARE
Adobe Photoshop

CATEGORY
Business

Automotive Society for Quality Control Magazine needed a contemporary illustration highlighting the new distinction in manufactured automobile parts. The premise was to depict actual elements in a very sophisticated style representing quality control.

Photographs and diagrams were scanned in Photoshop and special filters were applied to the images. They were then assembled in layers to form a combined collage effect. Multiple backgrounds, intersected by elements of type, were linked together to create the final illustration.

The colorful interaction of digital manipulation and ordinary parts is connected to form a provocative design. This intriguing high-tech illustration reflects the latest advancements in manufactured automobile parts. Eric Yang's fresh approach is typical of his unique ability to transform a traditional subject into an effective and meaningful image.

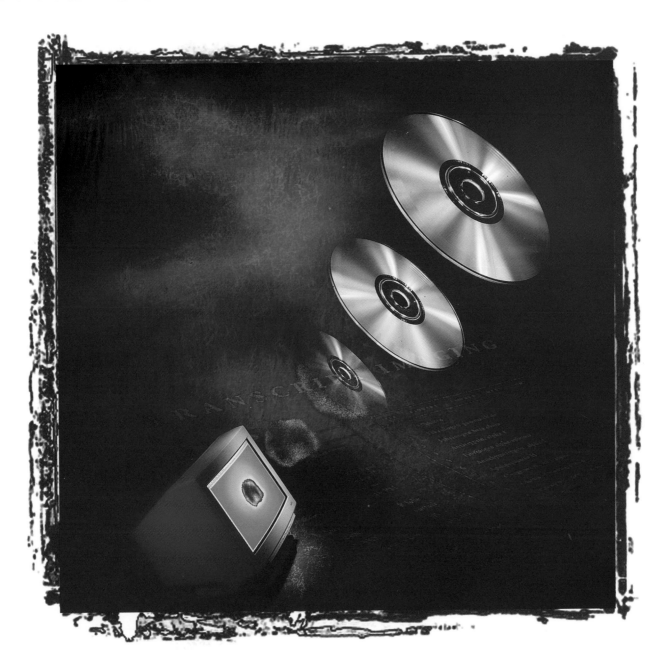

GEOFFREY
NELSON

In this advertisement depicting CD Disk Transcript Imaging software, Geoffrey Nelson brings clarity and understanding to a highly complicated scientific product. Using concise imagery, he visually describes the process of deciphering and decoding the most complex computer code — human DNA. The power of the product is forcefully accentuated by a surreal and almost magical background.

Photographic components were scanned and brought into Adobe Photoshop. The cell image on the computer screen was given the illusion of morphing into the CD-ROM through the use of scale, careful filtration, and blending. Color values and luminance were selected to focus attention. The text elements were then adjusted to display a subliminal effect.

This simple elaboration offers a clear illustration of an important medical research tool. With his precise style, Nelson clearly presents the integration of data, visual information and the latest in technology.

PHOTOGRAPHER
Geoffrey Nelson

DIGITAL CREATIVE
Hausman Design

CLIENT
INCYTE

SOFTWARE
Adobe Photoshop

CATEGORY
Business

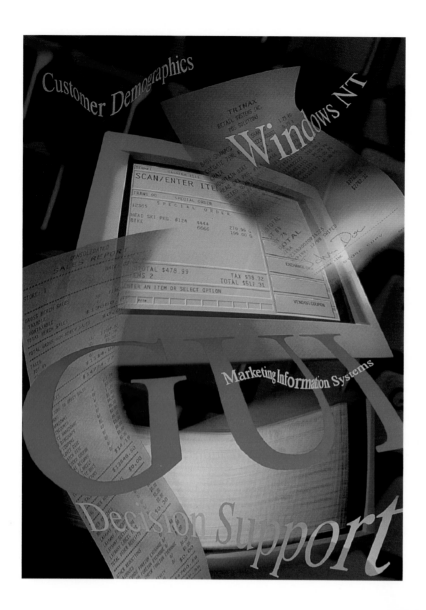

GUI

PHOTOGRAPHER
Ken Davies

DIGITAL CREATIVE
Ken Davies

CLIENT
Trimax Retail Systems

SOFTWARE
Adobe Photoshop

CATEGORY
Business

APPLIED INTELLIGENCE COVER

ILLUSTRATOR
Jeff Brice

CLIENT
Stewart Monderer Design

SOFTWARE
Adobe Photoshop,
Specular Collage

CATEGORY
Business

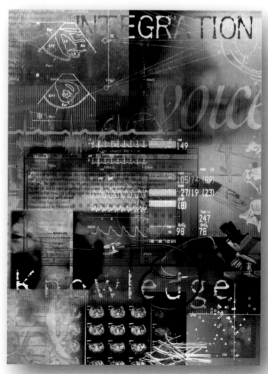

BUSINESS

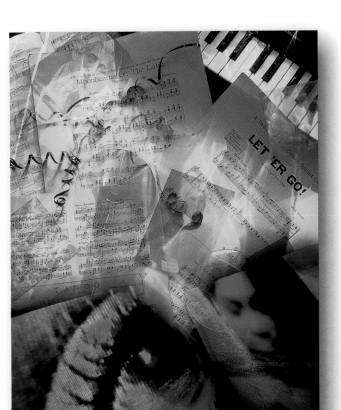

MUSIC PUBLICATION COVER

PHOTOGRAPHER
Ken Davies

DIGITAL CREATIVE
Ken Davies

CLIENT
Ink-Colour Expert

SOFTWARE
Adobe Photoshop

CATEGORY
Business

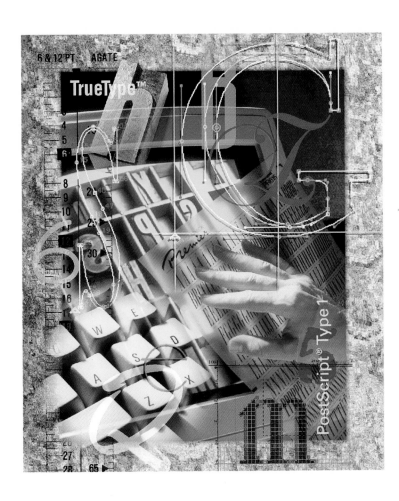

FONTEK PACKAGING ART

PHOTOGRAPHER
Dan Marcolina

DIGITAL CREATIVE
Dan Marcolina

CLIENT
Letraset

SOFTWARE
Color Studio

CATEGORY
Packaging

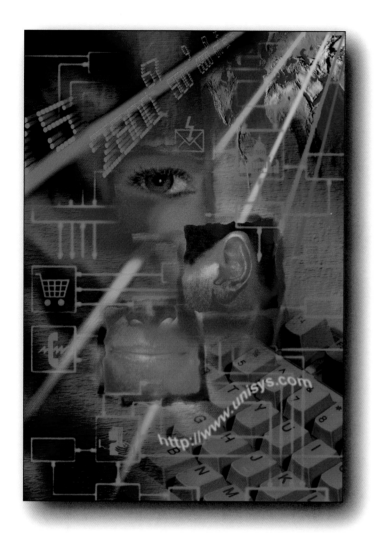

ELECTRONIC COMMERCE

PHOTOGRAPHER
William Whitehurst

DIGITAL CREATIVE
William Whitehurst

CLIENT
Unisys

SOFTWARE
Adobe Photoshop, Live Picture

CATEGORY
Corporate Brochure

INTERNET KEYS

PHOTOGRAPHER
William Whitehurst

DIGITAL CREATIVE
William Whitehurst

CLIENT
TSM

SOFTWARE
Adobe Photoshop

CATEGORY
Business

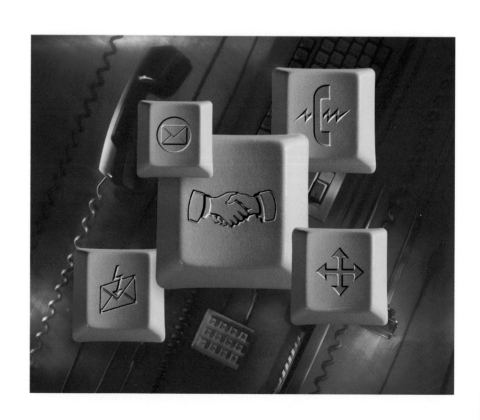

EFI-FIREY 200I

PHOTOGRAPHER
Stan Musilek

DIGITAL CREATIVE
Stan Musilek

CLIENT
EFI

SOFTWARE
Live Pictures

CATEGORY
Advertising

PROGRAMMER

PHOTOGRAPHER
Bob Schlowsky

DIGITAL CREATIVE
Lois Schlowsky

CLIENT
Tony Stone Images

SOFTWARE
QFX, Adobe Photoshop

CATEGORY
Stock Digital Illustration

FIBEROPTICS AROUND THE WORLD

PHOTOGRAPHER
William Whitehurst

DIGITAL CREATIVE
William Whitehurst

CLIENT
TSM

SOFTWARE
Adobe Photoshop,
Live Picture,
Strata Studio Pro

CATEGORY
Business

GLOBE & HAND

PHOTOGRAPHER
Geoffrey Nelson

DIGITAL CREATIVE
Janet Brockett/Elements

CLIENT
Applied Materials

SOFTWARE
Adobe Photoshop

CATEGORY
Business

BUSINESS

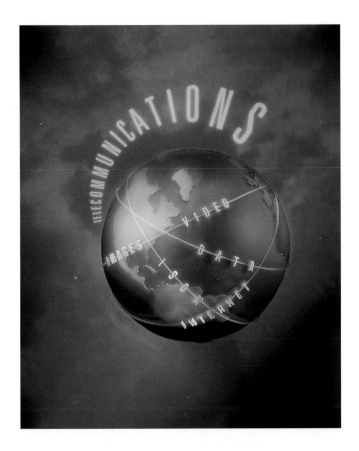

GLOBE TELECOMMUNICATIONS

PHOTOGRAPHER
Geoffrey Nelson

DIGITAL CREATIVE
Gordon Mortensen

CLIENT
Uniphase

SOFTWARE
Adobe Photoshop

CATEGORY
Business

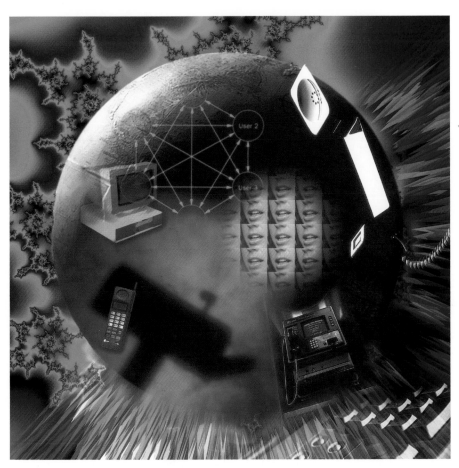

TELECOMMUNICATIONS GLOBE

PHOTOGRAPHER
Bill Milne

DIGITAL CREATIVE
Bill Milne

CLIENT
AT&T

SOFTWARE
Adobe Photoshop

CATEGORY
Advertising

TELECOMMUNICATIONS

PHOTOGRAPHER
William Whitehurst

DIGITAL CREATIVE
William Whitehurst

CLIENT
Helicon

SOFTWARE
Adobe Photoshop, Live Picture

CATEGORY
Business

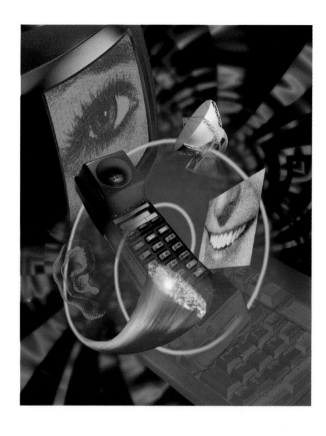

VOICE VIDEO IMAGE

PHOTOGRAPHER
Dan Marcolina, Stock

DIGITAL CREATIVE
Dan Marcolina

CLIENT
GTE Corporation

SOFTWARE
Adobe Photoshop, Specular Collage

CATEGORY
Business

BUSINESS

IDEA

PHOTOGRAPHER

DIGITAL CREATIVE
Eric Yang

CLIENT
U.S. Postal Service

SOFTWARE
Adobe Photoshop

CATEGORY
Government

PRIORITY MAIL

DIGITAL CREATIVE
Eric Yang

CLIENT
U.S. Postal Service

SOFTWARE
Adobe Photoshop

CATEGORY
Government

HEAD MULTIDIMENSIONAL

PHOTOGRAPHER
Geoffrey Nelson

DIGITAL CREATIVE
Ann Sison/1185 Design

CLIENT
Informix

SOFTWARE
Adobe Photoshop

CATEGORY
Business

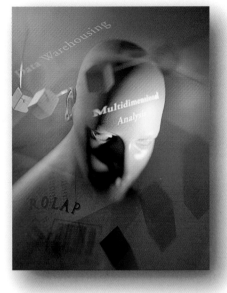

HEAD PLANE, REFLECTIVE SPHERE

PHOTOGRAPHER
Geoffrey Nelson

DIGITAL CREATIVE
Vernon Head/VGB

CLIENT
Phillips

SOFTWARE
Adobe Photoshop

CATEGORY
Business

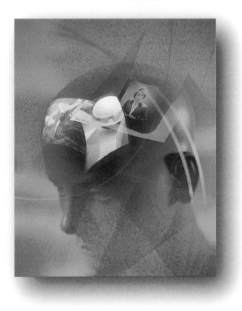

OPEX

PHOTOGRAPHER
Dan Marcolina

DIGITAL CREATIVE
Dan Marcolina

CLIENT
Opex

SOFTWARE
Adobe Photoshop

CATEGORY
Business

BUSINESS

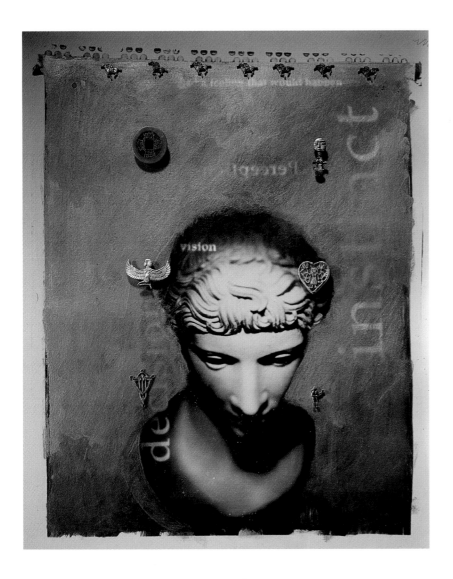

SCULPTURE HEAD

PHOTOGRAPHER
Geoffrey Nelson

DIGITAL CREATIVES
Rich Nelson, Mark Anderson Design

SOFTWARE
Adobe Photoshop

CATEGORY
Business

HEAD MULTIMEDIA

PHOTOGRAPHER
Geoffrey Nelson

DIGITAL CREATIVE
Vernon Head/VGB

CLIENT
Phillips

SOFTWARE
Adobe Photoshop

CATEGORY
Business

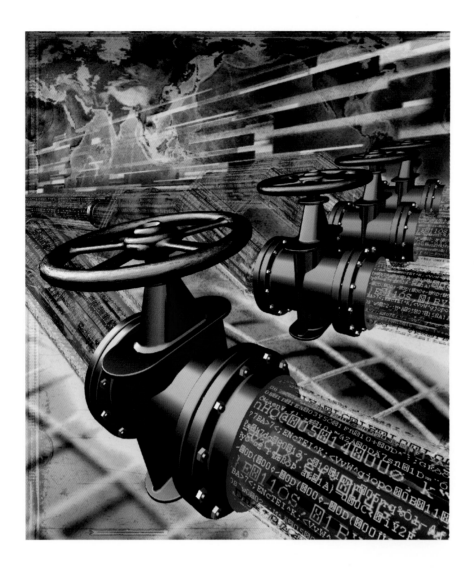

DAT PIPE

DIGITAL CREATIVE
Rob Magiera

CLIENT
Transcapacity

SOFTWARE
**Adobe Photoshop,
Alias Power Animator**

CATEGORY
Corporate

MAP PIPE

DIGITAL CREATIVE
Rob Magiera

CLIENT
Transcapacity

SOFTWARE
**Adobe Photoshop,
Alias Power Animator**

CATEGORY
Corporate

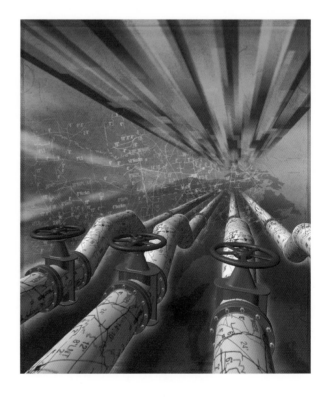

MAN AT COMPUTER

PHOTOGRAPHER
Ken Davies

DIGITAL CREATIVE
Ken Davies

CLIENT
ATI

SOFTWARE
Adobe Photoshop

CATEGORY
Annual Report

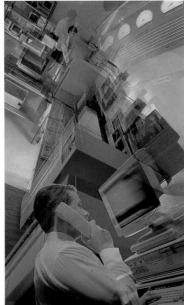

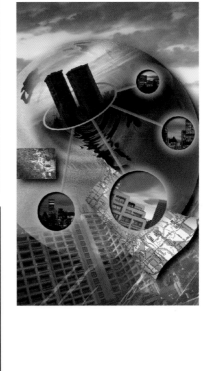

NETWORKING

PHOTOGRAPHER
Bill Milne

DIGITAL CREATIVE
Bill Milne

CLIENT
AT&T

SOFTWARE
Adobe Photoshop

CATEGORY
Advertising

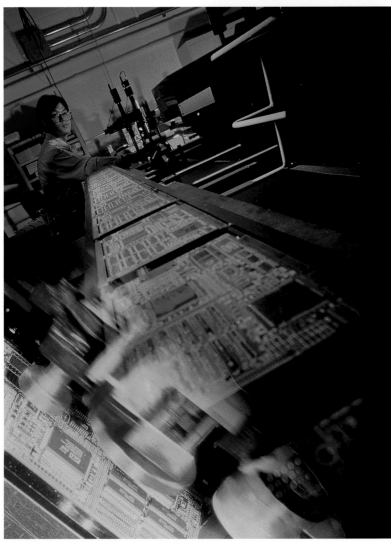

CIRCUIT BOARD VIEWPOINT

PHOTOGRAPHER
Ken Davies

DIGITAL CREATIVE
Ken Davies

CLIENT
ATI

SOFTWARE
Adobe Photoshop

CATEGORY
Business

ELECTRIC COMMERCE

DIGITAL CREATIVE
Eric Yang

CLIENT
Computer Science Corporation

SOFTWARE
Adobe Photoshop

CATEGORY
Corporate Brochure

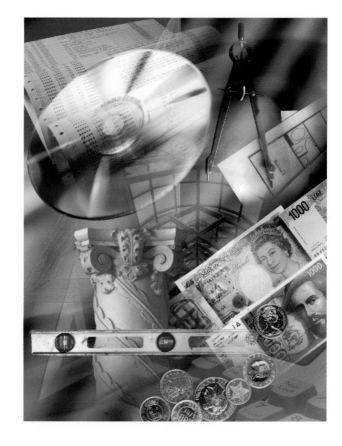

WILMINGTON TRUST ANNUAL REPORT

PHOTOGRAPHER
Dan Marcolina/Video

DIGITAL CREATIVE
Dan Marcolina

CLIENT
Wilmington Trust

SOFTWARE
Video Capture, Adobe Photoshop

CATEGORY
Annual Report

BUSINESS

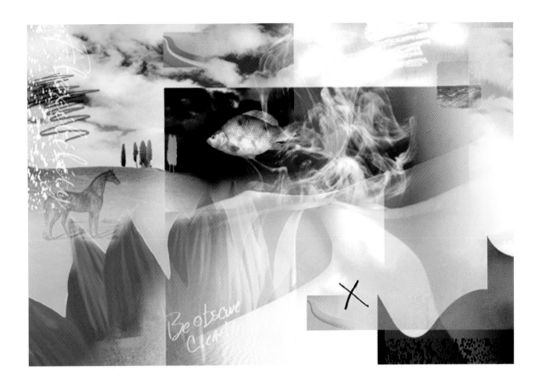

ITC DESIGN PALLET

PHOTOGRAPHER
Various

DIGITAL CREATIVE
Dan Marcolina

CLIENT
International Typeface Corporation

SOFTWARE
Adobe Photoshop, Specular Collage

CATEGORY
Business

BRINGING YOUR VISION TO THE NEXT LEVEL

DIGITAL CREATIVE
Dan Marcolina

CLIENT
Sun Microsystems

SOFTWARE
Adobe Photoshop, Specular Collage, Infini-D

CATEGORY
Business

VIRGIN GAMES COVER

PHOTOGRAPHERS
Ronald Dunlap, Bill Brewer

DIGITAL CREATIVES
Ronald Dunlap, Tony Honkawa

CLIENT
Virgin Games

SOFTWARE
Adobe Photoshop

CATEGORY
Business

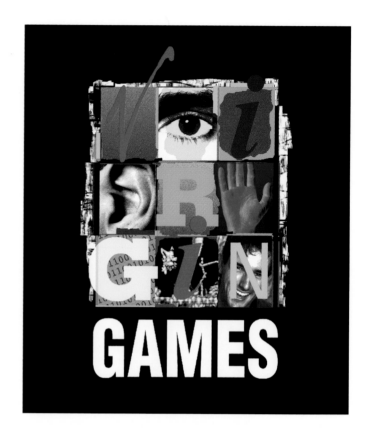

TAWERET'S GAME

PHOTOGRAPHER
Ronald Dunlap

DIGITAL CREATIVE
Ronald Dunlap

CLIENT
Dogbyte Development

SOFTWARE
Adobe Photoshop

CATEGORY
Business

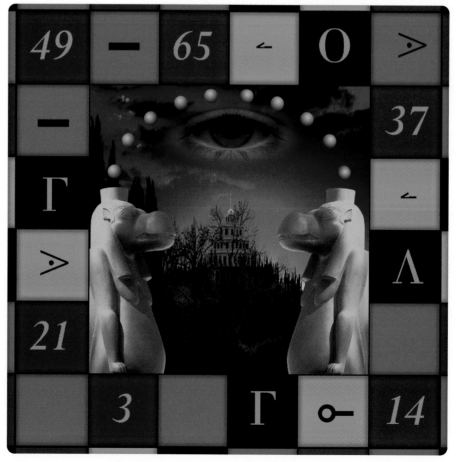

BUSINESS

MOTION SOUND & VISION

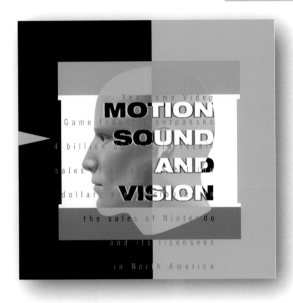

PHOTOGRAPHER
Ronald Dunlap

DIGITAL CREATIVE
Ronald Dunlap

CLIENT
Virgin Games

SOFTWARE
Adobe Photoshop

CATEGORY
Business

VITAMIN PACKAGING

PHOTOGRAPHER
Bill Milne

DIGITAL CREATIVE
Bill Milne

CLIENT
Life Science Nutritional

SOFTWARE
Adobe Photoshop, Poser,
Adobe Illustrator

CATEGORY
Advertising

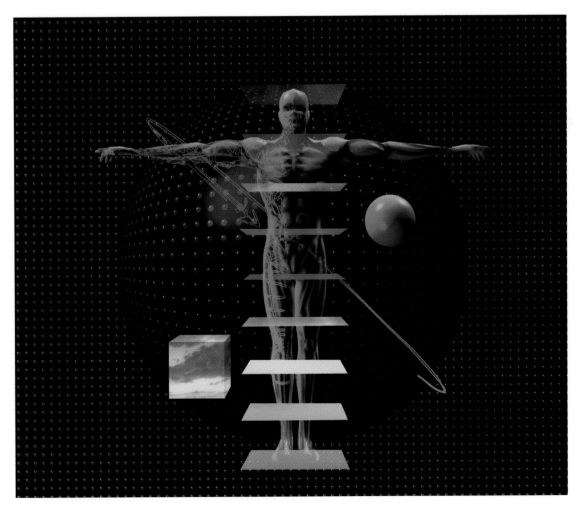

COMPUTER MONITOR CALLER ID

PHOTOGRAPHER
Geoffrey Nelson

DIGITAL CREATIVE
Marc Eis, Shugart/Matson

CLIENT
Pacific Bell

SOFTWARE
Adobe Photoshop

CATEGORY
Business

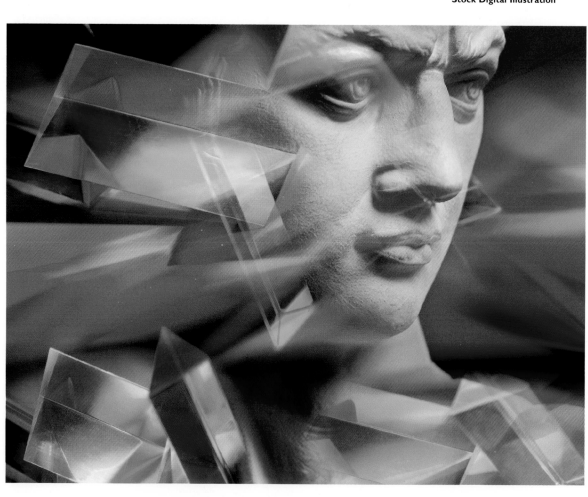

PRISMS WITH DAVID

PHOTOGRAPHER
Bob Schlowsky

DIGITAL CREATIVE
Lois Schlowsky

CLIENT
Tony Stone Images

SOFTWARE
QFX, Adobe Photoshop

CATEGORY
Stock Digital Illustration

BUSINESS

HAND GLOBE

PHOTOGRAPHER
Geoffrey Nelson

DIGITAL CREATIVE
Rich Nelson/CKS

SOFTWARE
Adobe Photoshop

CATEGORY
Business

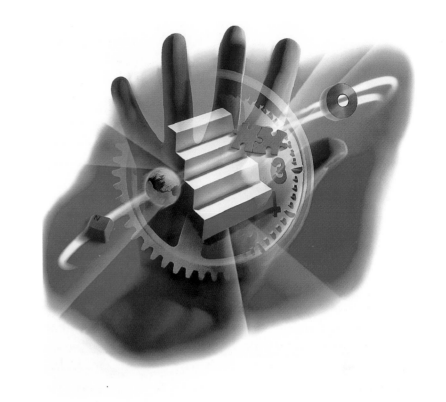

INTERNATIONAL BANKING

PHOTOGRAPHER
Bob Schlowsky

DIGITAL CREATIVE
Lois Schlowsky

CLIENT
Tony Stone Images

SOFTWARE
QFX, Adobe Photoshop

CATEGORY
Stock Digital Illustration

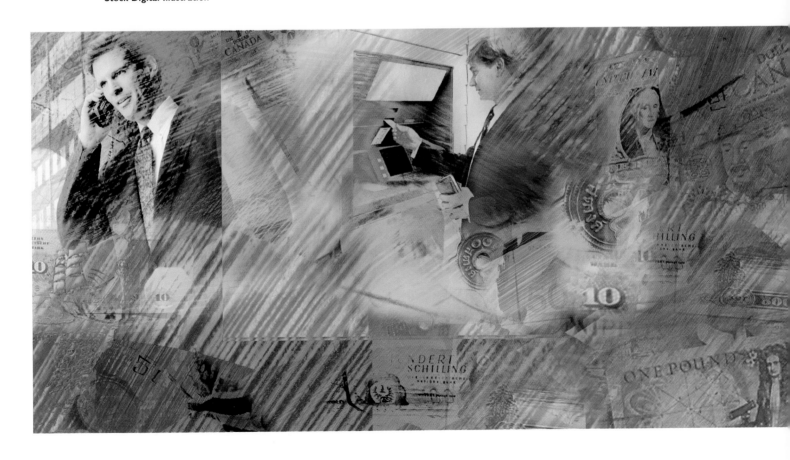

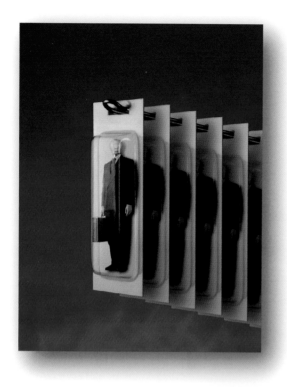

PAK MAN

PHOTOGRAPHER
Rick Dunn

DIGITAL CREATIVE
Rick Dunn

CLIENT
Brown Brothers, U.K.

SOFTWARE
Adobe Photoshop

CATEGORY
Advertising

WEB DESIGN/STOCK SHOT

PHOTOGRAPHER
Bill Milne

DIGITAL CREATIVE
Bill Milne

CLIENT
AT&T

SOFTWARE
Adobe Photoshop

CATEGORY
Business Publication

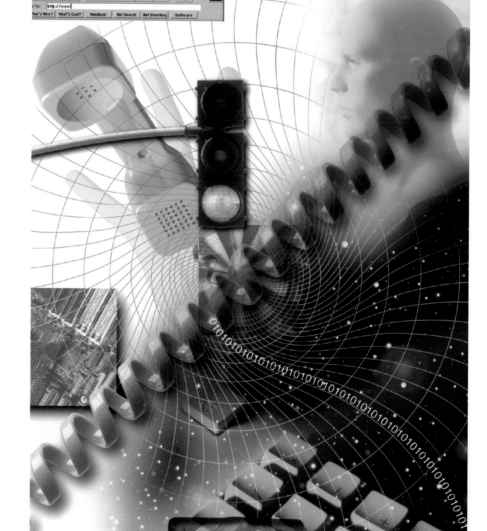

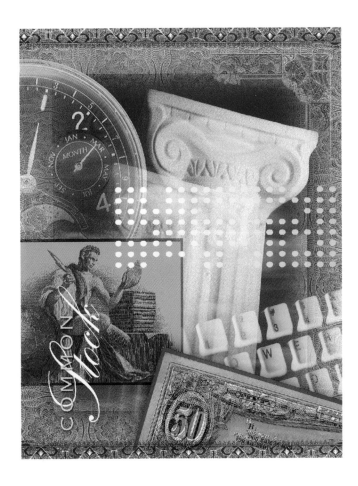

DEAN WITTER COMMON STOCK

DIGITAL CREATIVE
Dan Marcolina

CLIENT
Dean Witter

SOFTWARE
Adobe Photoshop

CATEGORY
Business

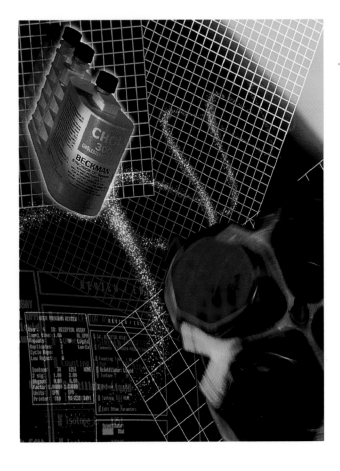

CHOL 300

DIGITAL CREATIVES
Shelly Beck, Tim Alt

CLIENT
Beckman Industries

SOFTWARE
Adobe Photoshop

CATEGORY
Business

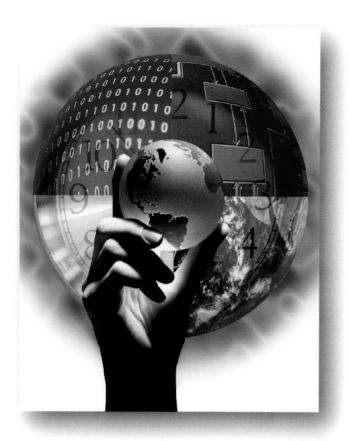

WORLD IN HAND

PHOTOGRAPHER
William Whitehurst

DIGITAL CREATIVE
William Whitehurst

CLIENT
TSM

SOFTWARE
Adobe Photoshop, Live Picture

CATEGORY
Business

CUBES & MONEY

PHOTOGRAPHER
Bob Schlowsky, Stock Images

DIGITAL CREATIVE
Lois Schlowsky

CLIENT
State Street Bank

SOFTWARE
QFX, Adobe Photoshop

CATEGORY
Business, Promotion

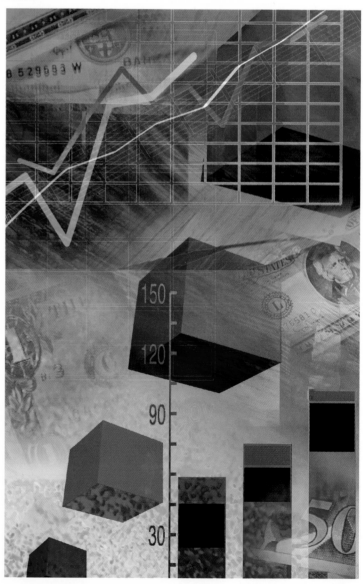

BUSINESS

FINANCIAL COLLAGE

PHOTOGRAPHER
William Whitehurst

DIGITAL CREATIVE
William Whitehurst

CLIENT
TSM

SOFTWARE
**Adobe Photoshop,
Specular Collage**

CATEGORY
Business

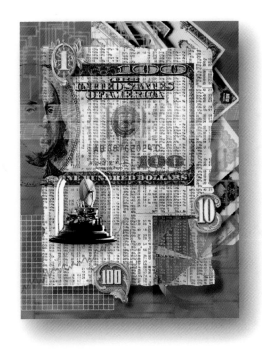

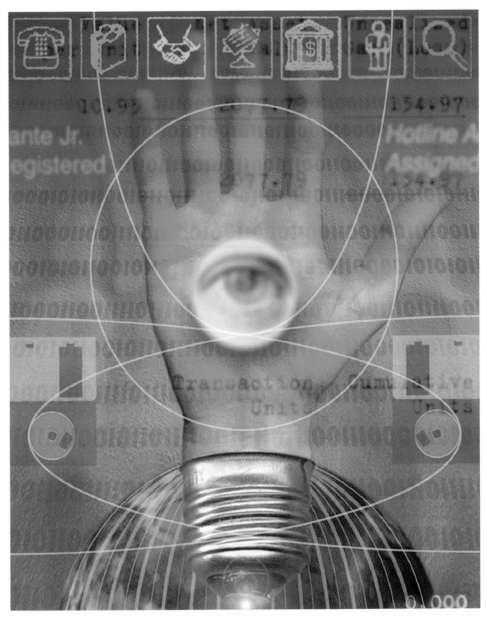

BUSCIPLINE

PHOTOGRAPHER
Paul Watson

DIGITAL CREATIVE
Paul Watson

CLIENT
Financial Planning Magazine

SOFTWARE
Adobe Photoshop

CATEGORY
Business

RESPONSECALL

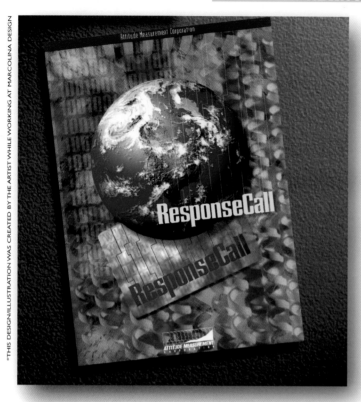

*THIS DESIGN/ILLUSTRATION WAS CREATED BY THE ARTIST WHILE WORKING AT MARCOLINA DESIGN

DIGITAL CREATIVE
Matthew Peacock*
Anonymous Productions

CLIENT
Attitude Measurement Corporation

SOFTWARE
Adobe Photoshop, Adobe Illustrator

CATEGORY
Business

AIRPLANES

PHOTOGRAPHER
Bob Schlowsky

DIGITAL

CREATIVE
Lois Schlowsky

CLIENT
RasterOps Annual
Report

SOFTWARE
QFX, Adobe
Photoshop

CATEGORY
Annual Report Cover

BUSINESS

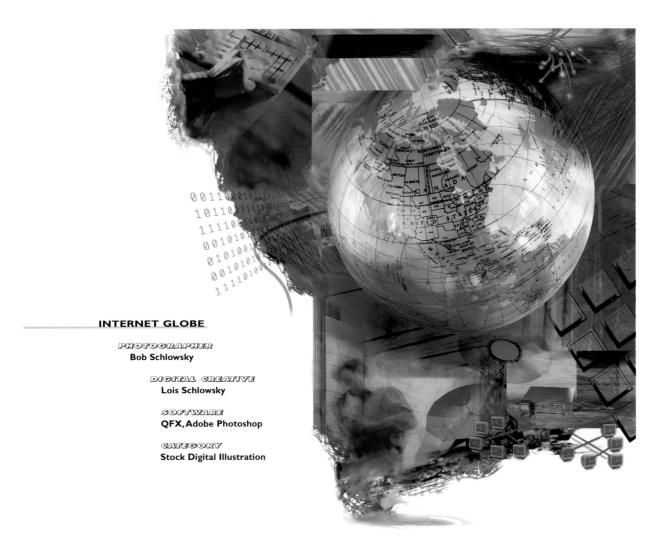

INTERNET GLOBE

PHOTOGRAPHER
Bob Schlowsky

DIGITAL CREATIVE
Lois Schlowsky

SOFTWARE
QFX, Adobe Photoshop

CATEGORY
Stock Digital Illustration

RACE CAR IN BUSINESS

PHOTOGRAPHER
Bob Schlowsky

DIGITAL CREATIVE
Lois Schlowsky

CLIENT
RasterOps Annual Report

SOFTWARE
QFX, Adobe Photoshop

CATEGORY
Annual Report Cover

Business *business*

people

PEOPLE

WATSON **PAUL**

PHOTOGRAPHER
Paul Watson

DIGITAL CREATIVE
Paul Watson

CLIENT
Mainstay Communications

SOFTWARE
Adobe Photoshop

CATEGORY
Editorial

This hypnotic editorial illustration by Paul Watson uses carefully chosen symbolic components to depict *Forecasting the Future of Finances in the Automotive Industry.* The figure, engine block and fiscal records are dynamically linked to reveal layers of metaphoric meaning.

Photographic transparencies of the various elements were scanned into Adobe Photoshop. They were then saved as individual layers with different degrees of opacity and the segments were juxtaposed to form a composition of asymmetric balance. Light and shadow were used to define and connect parts of the design. The contrast of a warm and cool color palette heighten the visual tension and impact of the illustration.

Through the subtle blending of key details and features, Watson is able to embed complex coded messages into seemingly simply visual structures. Working from his studio in Toronto, he uses the digital medium to create somewhat eerie and compelling effects and reveals uncommon and exciting design solutions.

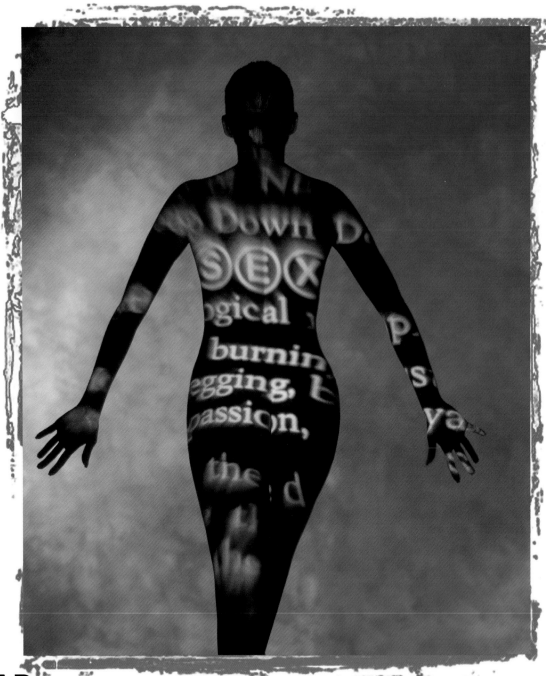

CAESAR LIMA

BODY LANGUAGE

PHOTOGRAPHER
Caesar Lima

DIGITAL CREATIVE
Caesar Lima

CLIENT
Caesar Photo Design, Inc.

SOFTWARE
Adobe Photoshop

CATEGORY
Self Promotion/Editorial

Dramatic and compelling, this image by Caesar Lima, of Caesar Photo Design, delivers an immediate message. Designed as a self-promotion, its meaning is conveyed by what is hidden and what is revealed. This provocative mood is captured and enhanced through the distorted words on the figure.

In constructing the image, traditional studio photography and digital manipulation techniques were combined in a unique way. Working in Adobe Illustrator and Photoshop, text elements were first developed and output in transparency form. The words were then projected on the silhouette shape of the model. The exact distance of the projection was critical in preventing it from appearing on the background. This striking use of light and language, depicted a subtle sense of illusion.

Born in Brazil, Caesar brings a unique, aesthetic slant to his work. Expanding the language of photography with digital manipulation, he pushes ideas to their limits—allowing mood and meaning to merge.

PEOPLE

FOUR FASHION FIGURES

PHOTOGRAPHER
Stan Musilek

DIGITAL CREATIVE
Stan Musilek

CLIENT
Vidal Sassoon

SOFTWARE
Live Pictures

CATEGORY
Advertising

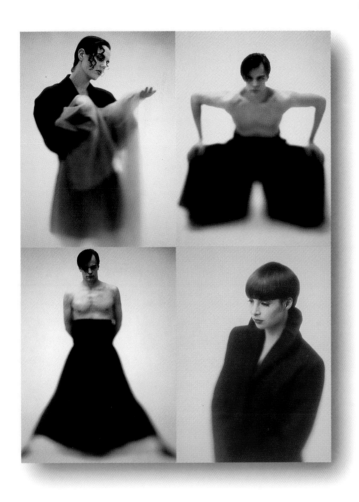

THE GIFT

PHOTOGRAPHERS
Sharon White/Bob Packert

DIGITAL CREATIVES
Sharon White/Bob Packert

CLIENT
White/Packert

SOFTWARE
Adobe Photoshop

CATEGORY
Christmas Card

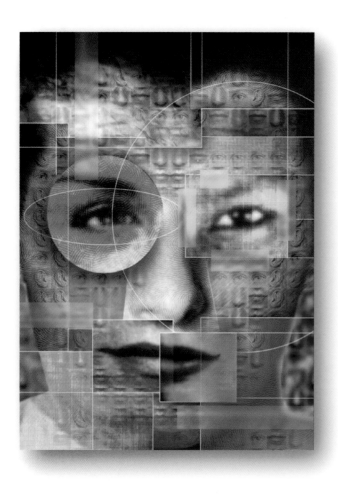

FACETED

PHOTOGRAPHER
Paul Watson

DIGITAL CREATIVE
Paul Watson

CLIENT
Physicians Management

SOFTWARE
Adobe Photoshop

CATEGORY
Editorial

BYTOWN EVOLUTE

PHOTOGRAPHER
Paul Watson

DIGITAL CREATIVE
Paul Watson

CLIENT
The Bytown Group

SOFTWARE
Adobe Photoshop

CATEGORY
Advertising

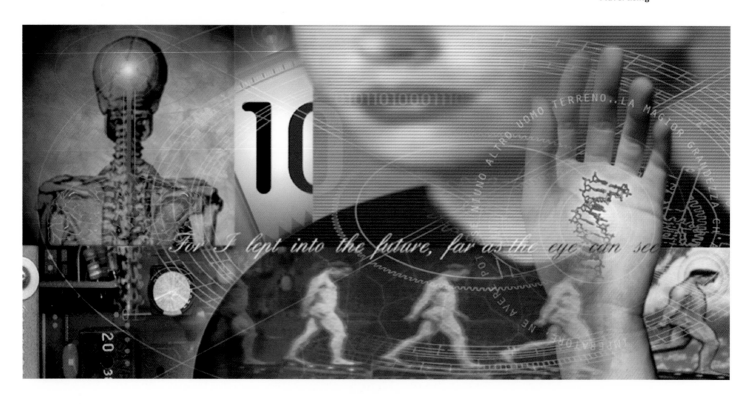

EVOL

PHOTOGRAPHER
Paul Watson

DIGITAL CREATIVE
Paul Watson

CLIENT
Equinox

SOFTWARE
Adobe Photoshop

CATEGORY
Editorial

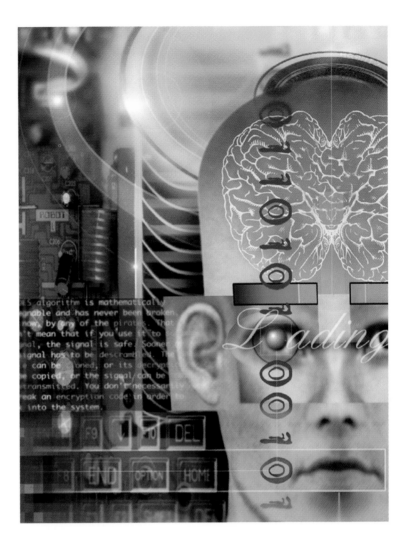

BRITTANY

PHOTOGRAPHER
Erik Osterling

DIGITAL CREATIVE
Rob Magiera

CLIENT
Personal

SOFTWARE
Adobe Photoshop

CATEGORY
Self Promotion

SEPIA FACE

PHOTOGRAPHER
Tom Collicott

DIGITAL CREATIVE
Tom Collicott

CLIENT
Microsoft

SOFTWARE
Adobe Photoshop

CATEGORY
Advertising

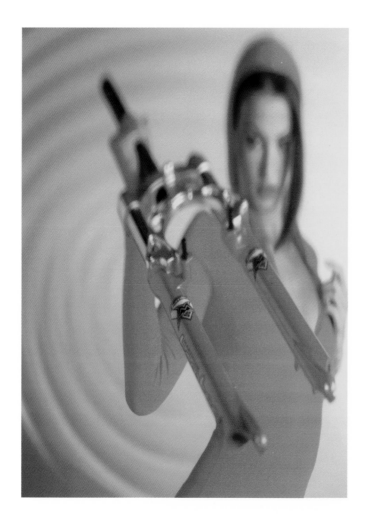

ZOK GIRL

PHOTOGRAPHER
Caesar Lima

DIGITAL CREATIVE
Caesar Lima

CLIENT
Marzocchi, Italy

SOFTWARE
Adobe Photoshop

CATEGORY
Advertising

MAN WITH COLLAR

PHOTOGRAPHER
Nick Koudis

DIGITAL CREATIVE
Koudis Nick

CLIENT
Comedy Central

SOFTWARE
Adobe Photoshop

CATEGORY
Advertising

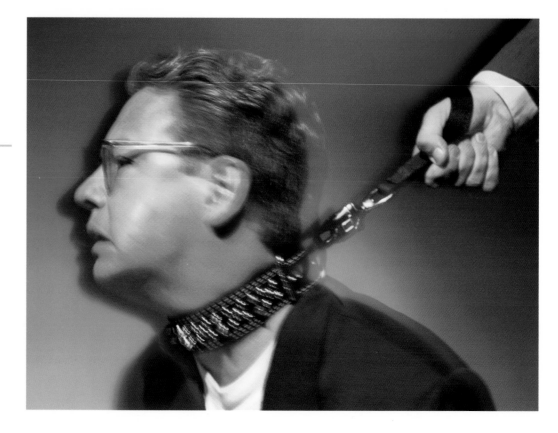

FLYING LAPTOP

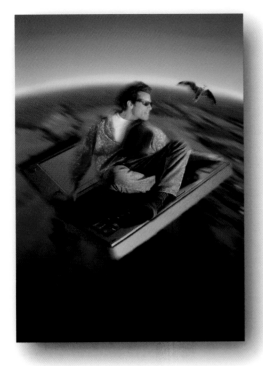

PHOTOGRAPHER
Nick Koudis

DIGITAL CREATIVE
Koudis Nick

CLIENT
Internet World Magazine

SOFTWARE
Adobe Photoshop

CATEGORY
Editorial

WOMAN WITH FISH

PHOTOGRAPHER
Ken Davies

DIGITAL CREATIVE
Ken Davies

CLIENT
Ink-Colour Expert

SOFTWARE
Adobe Photoshop

CATEGORY
Business

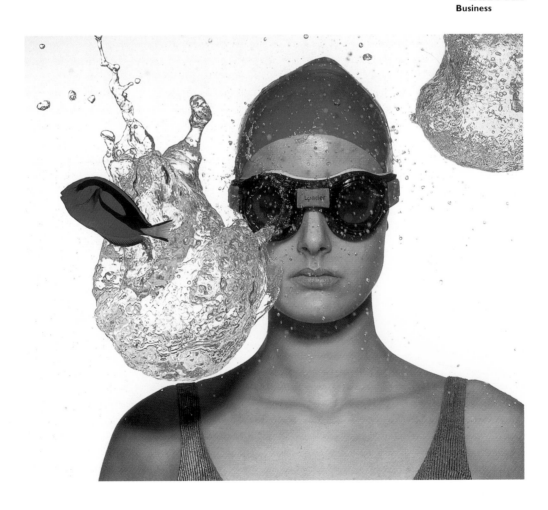

THINKER

PHOTOGRAPHER
Tim Alt

DIGITAL CREATIVE
Tim Alt

SOFTWARE
Electric Image

CATEGORY
Stock

HEAD WITH STRIPES

PHOTOGRAPHER
Tim Alt

DIGITAL CREATIVE
Tim Alt

SOFTWARE
Photoshop, Texture Scape

CATEGORY
Stock

TWO HEADS

PHOTOGRAPHER
Tim Alt

DIGITAL CREATIVE
Tim Alt

SOFTWARE
Adobe Photoshop, Strata 3D,
Macromedia Freehand

CATEGORY
Stock

TOPOGRAPHICAL FACE

PHOTOGRAPHER
Tim Alt

DIGITAL CREATIVE
Tim Alt

SOFTWARE
Electric Image

CATEGORY
Stock

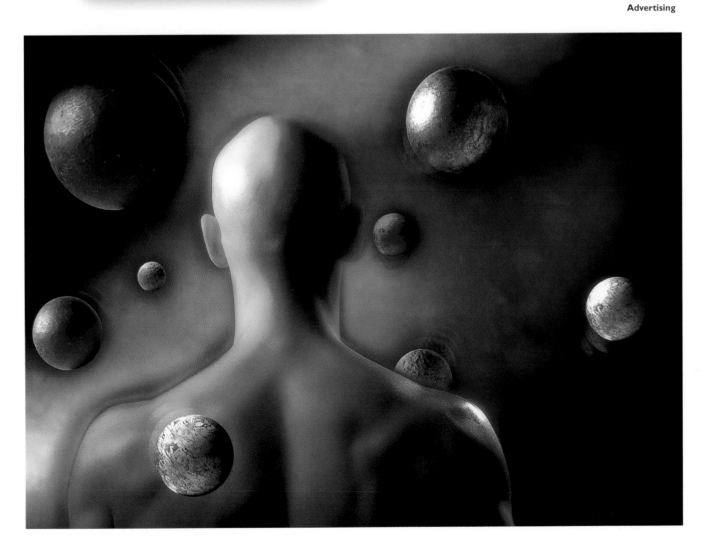

CONCEPTUAL SPHERES

PHOTOGRAPHER
Richard Wahlstrom

DIGITAL CREATIVE
Richard Wahlstrom

CLIENT
Ascend

SOFTWARE
Adobe Photoshop

CATEGORY
Advertising

VICE HEAD

PHOTOGRAPHER
Barry Blackman

DIGITAL CREATIVE
Barry Blackman

CLIENT
Rx

SOFTWARE
Barco Creator

CATEGORY
Promotion

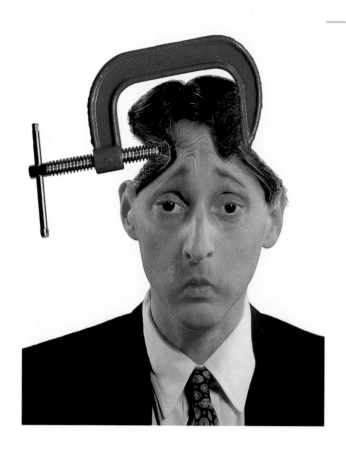

CRAZED JUDGE

PHOTOGRAPHER
J.W. Burkey

DIGITAL CREATIVE
J.W. Burkey

CLIENT
Stock Image

SOFTWARE
Adobe Photoshop

CATEGORY
Stock

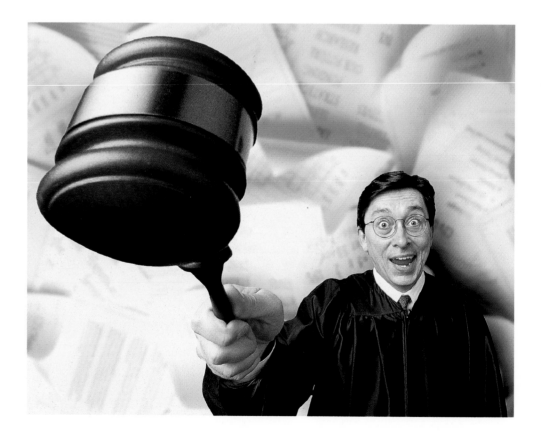

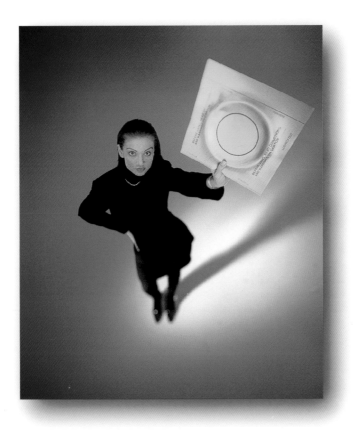

CONDOM GIRL

PHOTOGRAPHER
Stan Musilek

DIGITAL CREATIVE
Stan Musilek

CLIENT
Stan Musilek

SOFTWARE
Live Pictures

CATEGORY
Self-Promotion

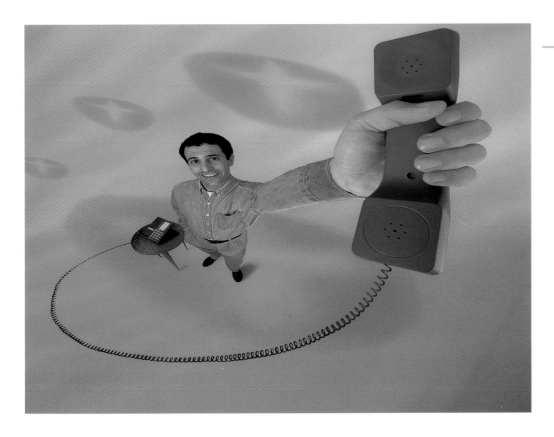

MAN WITH PHONE

PHOTOGRAPHER
Ken Davies

DIGITAL CREATIVE
Ken Davies

CLIENT
Citibank

SOFTWARE
Adobe Photoshop

CATEGORY
Advertising

PORTRAIT #3

PHOTOGRAPHER
Daniel Arsnault

DIGITAL CREATIVE
Rob Magiera

CLIENT
Discovery Magazine

SOFTWARE
Adobe Photoshop

CATEGORY
Editorial

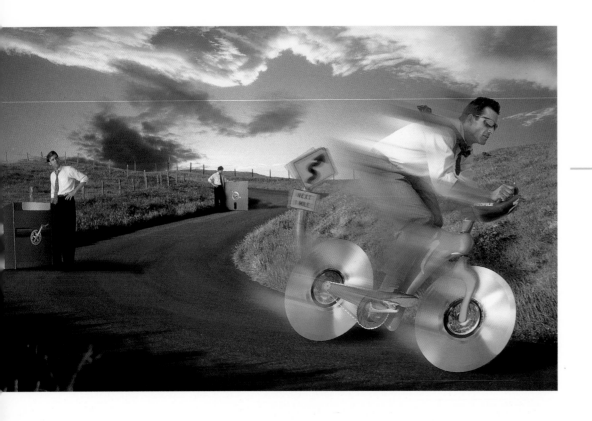

BIKER

PHOTOGRAPHER
Richard Wahlstrom

DIGITAL CREATIVE
Richard Wahlstrom

CLIENT
Sony

SOFTWARE
Adobe Photoshop

CATEGORY
Advertising

PORTRAIT #2

PHOTOGRAPHER
Daniel Arsnault

DIGITAL CREATIVE
Rob Magiera

CLIENT
Discovery Magazine

SOFTWARE
Adobe Photoshop

CATEGORY
Editorial

NEW AGE ELDERLY

PHOTOGRAPHER
Ed Lowe

DIGITAL CREATIVE
Philip Howe

CLIENT
Kiwanis

SOFTWARE
Adobe Photoshop, Fractal
Design's Painter

CATEGORY
Editorial

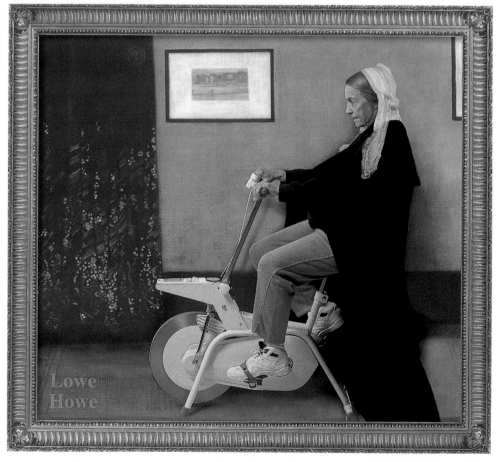

MEDIA

media

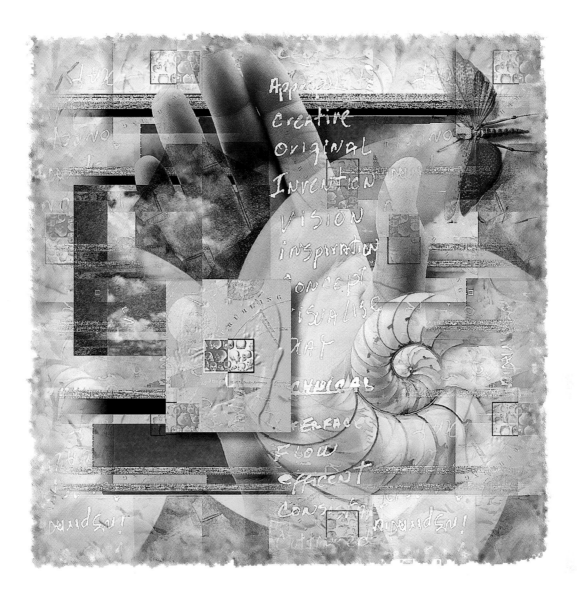

MARCOLINA DESIGN

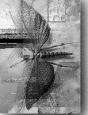

Blending organic hand-crafted qualities with high-tech overtones, this illustration by Marcolina Design, Inc. was used as an interface on their promotional CD-ROM. Conceived to capture the essence and philosophy of the studio, it gracefully balances powerful technology with imaginative beauty. Soft textures and natural objects are translucently overlaid, suggesting growing insight. This is enhanced by the repetition of a window pattern which diffuses through the entire design.

This image was assembled and fashioned in Specular Collage. Working intuitively, the original source imagery was amassed from the studio's CD-ROM collection. Adobe Photoshop was used for masking, color correction, and the integration of text. The final effect incorporates a gentle range of tones and a sense of infinite depth.

With more than fifteen years of experience, Marcolina Design, Inc. is a premiere design and multimedia studio. In this imaginative illustration, they offer a playful example of their design capabilities — while demonstrating part of their versatile design philosophy.

DIGITAL DEXTERITY

PHOTOGRAPHER
Dan Marcolina

DIGITAL CREATIVES
Dan Marcolina,
Denise Marcolina,
Dermot MacCormack,
Sean McCabe,
Quinn Richardson,
Mike Lingle,
Matt Peacock

CLIENT
Marcolina Design, Inc.

SOFTWARE
Adobe Photoshop,
Specular Collage

CATEGORY
CD Rom/Interactive

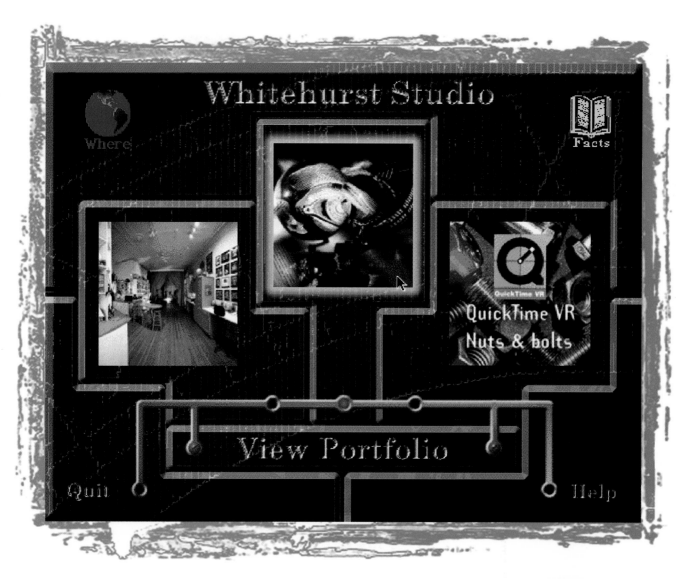

WILLIAM WHITEHURST

Travel though dimensional space is placed at the viewers finger tips in William Whitehurst's self-promotional CD-ROM. A panoramic photograph of his studio becomes a virtual adventure with the click of the mouse. With total flexibility of motion, it is possible to explore his workspace and even read book titles on the bookshelves. This amazing virtual experience is imaginable through the latest advances in computer technology.

Developed to provide interactive insight into the Whitehurst Studio, the disk offers viewers an opportunity to wander through space and see several different portfolios. It also contains demonstrations of how QuickTimeVR can be used as a conceptual tool. One can navigate through the ideas depicted and select specific information to explore. This new technology also includes an introductory lesson on the interactive interface. The main

WHITEHURST STUDIO

INTERACTIVE CD-ROM

PHOTOGRAPHER
William Whitehurst

DIGITAL CREATIVE
William Whitehurst

CLIENT
Whitehurst Studio

SOFTWARE
**QuicktimeVR,
Apple Media Tool**

CATEGORY
Media

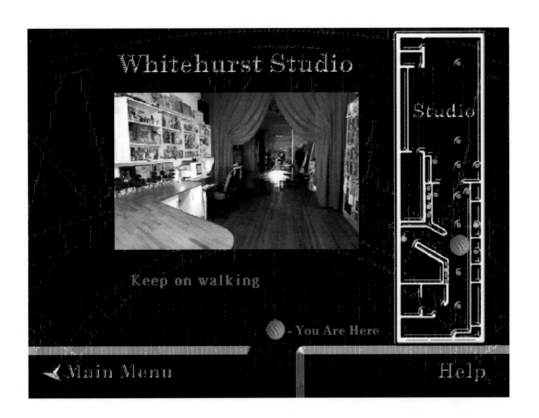

menu invites viewers to choose where to go and what to investigate. Traditional Photography, Digital Imagery and QuickTimeVR tours are all featured in this powerhouse project.

QuickTimeVR converts a photograph into a full motion interaction. Numerous screens and menus were fashioned in Adobe Photoshop. The interface, was generated in Apple Media Tool. Individual images included in the portfolios were created using traditional photography, and both Live Picture and Adobe Photoshop. The overall purpose of the CD's interface was developed to match the style and feel of the dynamic design solutions offered by Whitehurst Studio. The final result is a breathtaking and effective promotional tool.

DALE GRAHAM

GREATER BOSTON ARTS

DESIGNER
Dale Graham

PRODUCER
Vicky Lemont

EDITOR
Peter Barstis

CLIENT
WGBH Boston

SOFTWARE
**Adobe Photoshop,
Adobe Illustrator**

CATEGORY
Broadcast Television

MEDIA

In this imaginative and innovative video for WGBH Boston Public Television both sound and picture get the full creative treatment. Developed to serve as a single promotion and opening sequence for a monthly arts program, Dale Graham and Vicky Lemont of Ouch, employed a cutting-edge approach with a limited budget to the best advantage.

Working with existing footage, they manipulated, and layered their materials. Aimed at uniting the sophistication and the high-energy of Boston, the video juxtaposed classical clips within distorted visual frames. High-speed images of upcoming programming were used to entice viewers, while animated text ran gracefully in sync to an operatic soundtrack.

Ouch pushes the limits of creativity with their wildly adventuresome and intelligent approach. Daring and dynamic their work is both invigorating and inspiring. They bring energy, technical skill and an uncommon vision to meet the toughest design challenges.

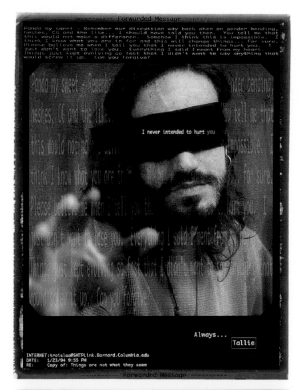

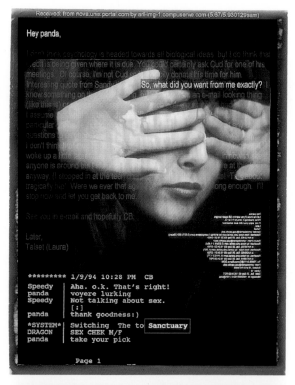

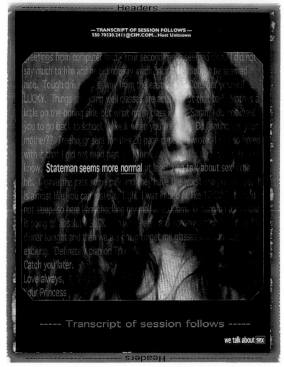

A.O.L. @

PHOTOGRAPHER
Mark Katzman

DIGITAL CREATIVE
Mark Katzman

CLIENT
Studio Promotion

SOFTWARE
Live Picture, Fractal Design's
Painter, Adobe Illustrator,
Adobe Photoshop

CATEGORY
Media

FRANZ PLAYTIME

PHOTOGRAPHER
Lance Jackson

DIGITAL CREATIVE
Andrea Sohn

CLIENT
Franz

SOFTWARE
Adobe Photoshop

CATEGORY
Software Packaging

CIRCUIT BOARD FACE

PHOTOGRAPHER
Barry Blackman

DIGITAL CREATIVE
Barry Blackman

CLIENT
Cyber Kinematic Productions, Ltd.

SOFTWARE
Barco Creator

CATEGORY
Web Site

89

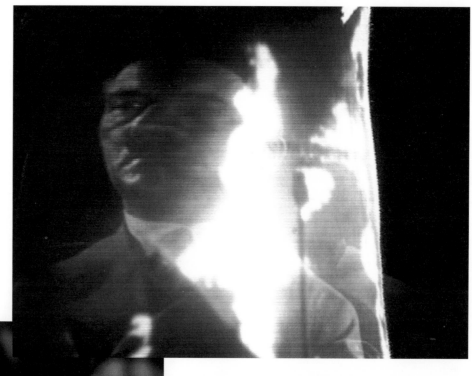

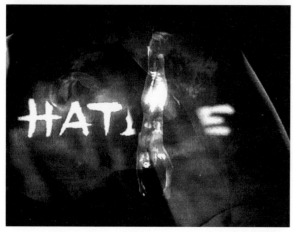

UNDERSTANDING HATE

DESIGNER
Dale Graham

DIRECTOR/PRODUCER
Scott Danielson

CLIENT
KTCA TV

SOFTWARE
Macromedia Freehand

CATEGORY
Broadcast Television

CINEMAX INTERSTITIAL OPENING GRAPHICS

DESIGNER
Dale Graham

PRODUCER
Vicky Lemont

EDITOR
Peter Barstis

CLIENT
Cinemax

SOFTWARE
Adobe Photoshop, Adobe Illustrator

CATEGORY
Cable Television

CHANNEL V PROMO

DESIGNER
Dale Graham

PRODUCER
Hatmaker

EDITOR
Peter Barstis

CLIENT
Star TV Asia

SOFTWARE
**Adobe Photoshop,
Adobe Illustrator**

CATEGORY
Cable Television

ẽ

DIGITAL CREATIVE
JRDG

CLIENT
Government of Spain

SOFTWARE
Adobe Illustrator, Adobe Photoshop,
Macromedia Director, Premiere,
Form Z, Electric Image

CATEGORY
CD Rom

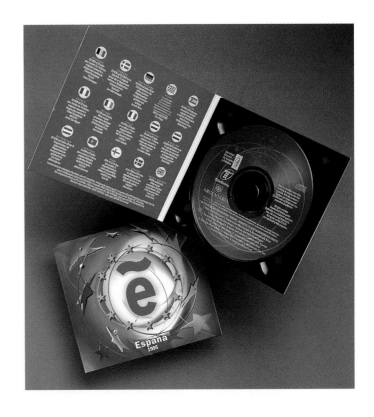

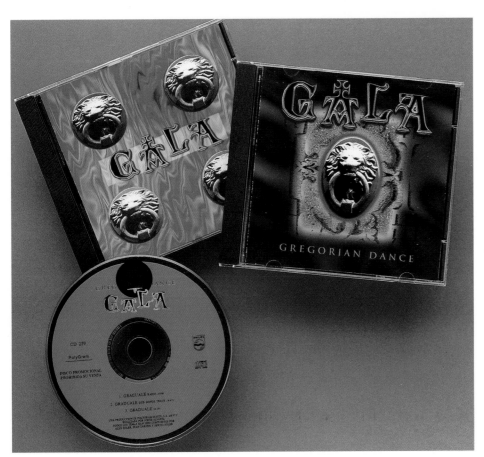

GALA

DIGITAL CREATIVE
JRDG

CLIENT
Polygram International

SOFTWARE
Adobe Illustrator, Adobe Photoshop, Kay

CATEGORY
Music CD Cassette Package

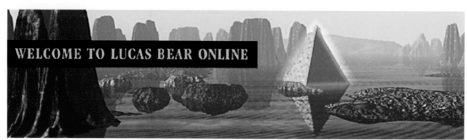

** THESE ILLUSTRATIONS WERE CREATED BY THE ARTIST WHILE WORKING AT MARCOLINA DESIGN, INC. / TYPE IMPLEMENTATION AND LUCAS BEAR LOGO DESIGN BY DAN MARCOLINA

LUCAS-BEAR ONLINE

DIGITAL CREATIVE
Matthew Peacock**/Anonymous
Productions

CLIENT
Lucas-Bear, Inc.

SOFTWARE
Adobe Photoshop, Adobe
Illustrator, Infini-D, KPT Bryce

CATEGORY
Media

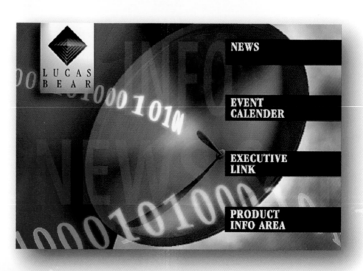

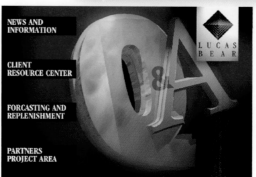

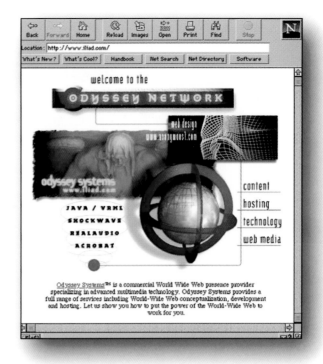

ODYSSEY SYSTEMS WEBSITE
(www.iliad.com)

DIGITAL CREATIVE
Matthew Peacock/Anonymous
Productions

CLIENT
Odyssey Systems Corporation

SOFTWARE
Adobe Photoshop, Adobe
Illustrator, Infini-D, Fractal
Design's Painter

CATEGORY
Media

IKON WEBSITE
(www.ikon.com)

DIGITAL CREATIVE
Matthew Peacock/Anonymous
Productions

CLIENT
IKON Office Solutions

SOFTWARE
Adobe Photoshop,
Adobe Illustrator,
Fractal's Design Painter

CATEGORY
Media

THE PATENT OFFICE

PHOTOGRAPHER
Stock, Henk Dawson

DIGITAL CREATIVE
Henk Dawson

CLIENT
Microsoft

SOFTWARE
Form Z, Electric Image,
Adobe Photoshop

CATEGORY
Online

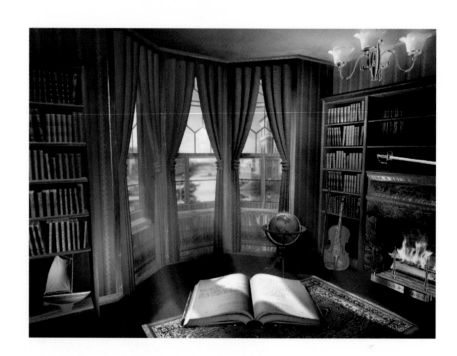

THE LIBRARY

PHOTOGRAPHER
Stock, Henk Dawson

DIGITAL CREATIVE
Henk Dawson

CLIENT
Microsoft

SOFTWARE
Form Z, Electric Image,
Adobe Photoshop

CATEGORY
Online

OBSERVATORY

PHOTOGRAPHER
Stock, Henk Dawson

DIGITAL CREATIVE
Henk Dawson

CLIENT
Microsoft

SOFTWARE
**Form Z, Electric Image,
Adobe Photoshop**

CATEGORY
Online

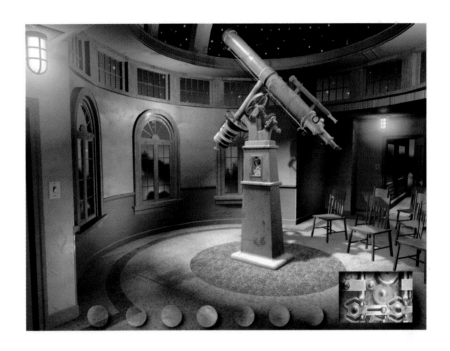

CONTROL TOWER

PHOTOGRAPHER
Mike Fizer

DIGITAL CREATIVE
Henk Dawson

CLIENT
Landor Associates

SOFTWARE
**Form Z, Electric Image,
Adobe Photoshop**

CATEGORY
Advertising

SURREAL

surreal

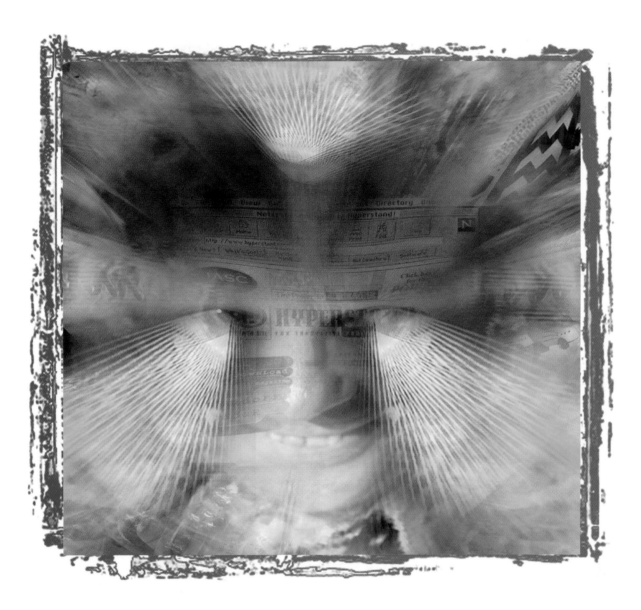

LANCE JACKSON

Commissioned as a cover assignment, this kinetic illustration demonstrates the audio and visual capabilities of the Internet. Alluding to wizards and superheros, Jackson has created a parody of happiness and self-enlightenment. Swirling with carnival ride action and color, the smiling figure becomes a wild embodiment of power.

Photographs and still-frames, captured from video, were imported into Adobe Photoshop. Jackson uses a variety of filters and effects to create the richly saturated colors. The kaleidoscopic motion and the artificial sense of atmosphere, add energy to the chaotic excitement of the image.

Jackson is the quintessential digital designer. Grounded in the history of illustration, painting and cult films, he uses the computer with confidence and pushes the limits of both photography and the electronic palette.

STREAMING FACE

PHOTOGRAPHER & VIDEO
Lance Jackson

DIGITAL CREATIVE
Nancy Cutler

CLIENT
New Media Magazine

SOFTWARE
Adobe Photoshop

CATEGORY
Editorial &
Self-Promotion

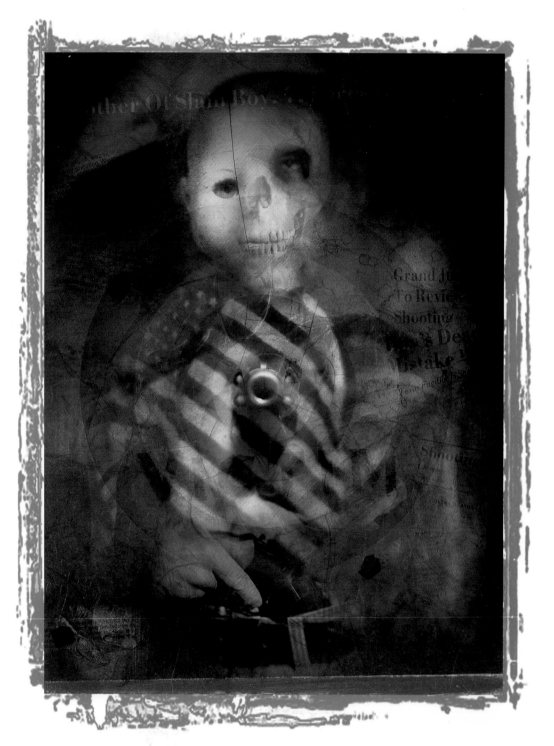

SURREAL

SCOTT

FERGUSON

GUNS IN AMERICA

PHOTOGRAPHER
Scott Ferguson

DIGITAL CREATIVE
Scott Ferguson

ART DIRECTOR
Richard Boddy

CLIENT
Discover Magazine

SOFTWARE
Live Picture,
Fractal Design's Painter,
Adobe Illustrator,
Adobe Photoshop

CATEGORY
Editorial

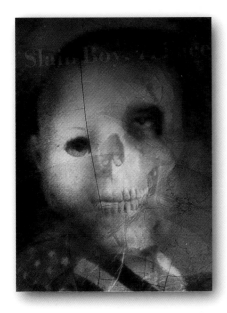

This haunting image of violence in America was created by Scott Ferguson, of Ferguson and Katzman Photography, for *Discover Magazine*. Provided with the storyline for an article on handgun abuse, Ferguson independently conceived and developed this complex, layered illustration. Brutally confrontational and unsettling, the foreboding image evokes a variety of subliminal messages.

Working initially in Live Picture, the primary photographic elements were collated and assembled. Once the basic composition was created, Adobe Photoshop was used for blending, precise channeling, and type treatment. A muted color range was incorporated to enhance both the dangerous uncertainty and the illustrative sense of the work.

Ferguson provides this image with a visual vocabulary as deeply complex and varied as the topic. Initially, the viewer is immediately drawn to the overlapped skull and face of the doll. The reaching hand and the barrel of the gun make a pointedly aggressive statement. The most ominous details remain hidden until the eye becomes acclimated to the darkness; only then do disturbing headlines, prone bodies and violent warnings emerge. This sophisticated approach, to even the most difficult concept, is a signature of Ferguson and Katzman Photography.

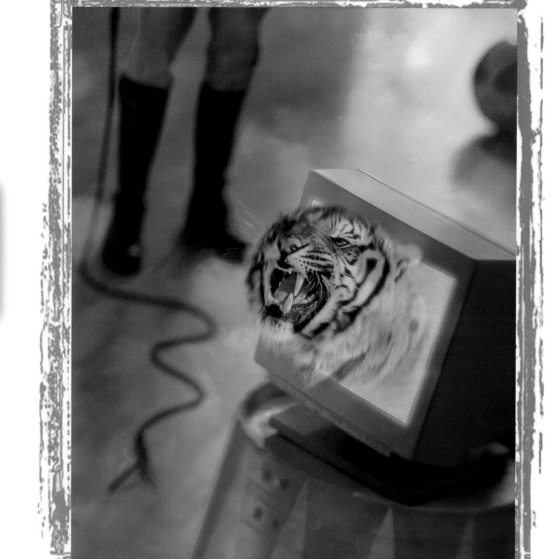

TOM COLLICOTT

TIGER TRAINER

PHOTOGRAPHER
Tom Collicott
Tiger:Image Bank Stock

DIGITAL CREATIVE
Tom Collicott

CLIENT
US News & World Report

SOFTWARE
Adobe Photoshop

CATEGORY
Editorial

This pleasing, mysterious image by Tom Collicott was originally designed to illustrate a *U.S. News and World Report* article entitled "Taming the Internet." Softly focusing on nuance and detail, the piece gently coaxes the viewer to complete its meaning. The tilted frame and intersection of visual elements, hint at danger — yet, the quiet colors and relaxed stance imply a calm readiness to face the task.

The image was assembled in Adobe Photoshop from three separate photographs. Collicott created the base picture of the ringmaster, barrel and computer screen; then, he imported the stock image of the tiger's head. The cloud texture was added to create atmosphere. Filters and color corrections were applied to create the soft focus and enhance the underlying mood of the work.

This beautifully balanced image includes only what is essential to convey its purpose. Typical of Collicott's sensitive style, he uncovers the fundamental concerns in the concepts, and finds visual answers that are both elegant and graceful.

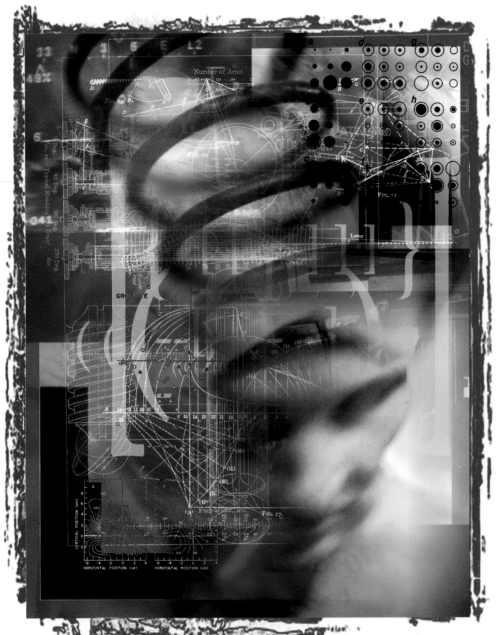

SPRINGHEAD

ILLUSTRATOR
Jeff Brice

SOFTWARE
**Adobe Photoshop,
Specular Collage**

CATEGORY
Promotion

JEFF BRICE

This self-promotional by Jeff Brice, suggests the process of turning ideas into actions by connecting the industrial with the human. Contemplative and sound, this work uses visual depth and overlapping imagery to explore the association between the informative and cognitive realms of the mind. The central theme of the spring provides a strong graphic impact, demonstrating the powerful energy of thought.

Initially, high resolution scans of photographs and diagrams were generated. To assemble and adjust the layout, low resolution proxies were created in Specular Collage. Working with proxies allowed the design process to flow in real time. Finally, using filters and special effects in Adobe Photoshop, blurring, opacity and color were manipulated.

In this dynamic examination of the creative process, Brice establishes a bridge between form and content. The beauty of the image is balanced by the ideas that it contains. His clear, visual, metaphoric sense allows him to use type, texture, translucence and layering in a complex yet most compelling way.

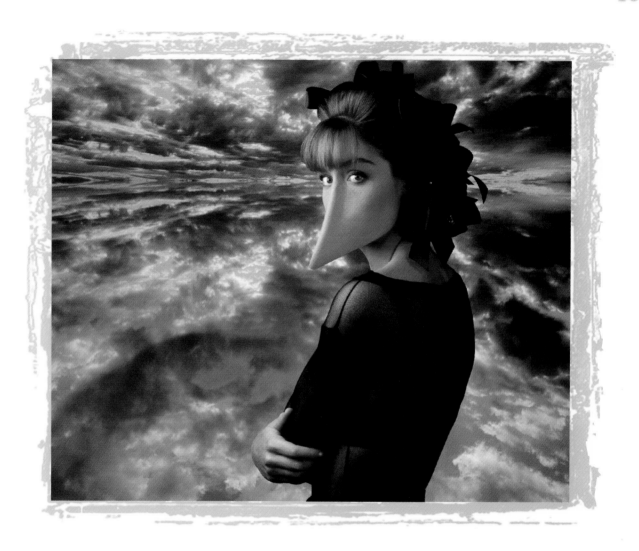

RICK DUNN

NOSE JOB

PHOTOGRAPHER
Rick Dunn

DIGITAL CREATIVE
Rick Dunn

CLIENT
Rick Dunn

SOFTWARE
Adobe Photoshop

CATEGORY
Promotion

Combining the familiar with the bizarre, Rick Dunn's self-promotion image is firmly planted in the tradition of the surreal. Using the language of the subconscious, what is normally understood becomes radically transformed. In this imaginative world, the viewer's disbelief is at once supported by the photo-realism of the image, yet called into question by the impossibility of the scene.

The photographic elements were first scanned into Adobe Photoshop. Dunn then used scaling, distortion and cloning to achieve the exaggerated facial effect. Visual noise was added to make the cloning closely match the original skin texture. A highly saturated color palette enhanced the mood of the image.

Rick Dunn enjoys fusing uncommon elements in his work. Interested in the line between reality and fiction, he has balanced photo-realism with fantasy to achieve his thought-provoking images. This illustration demonstrates an intuitive creative process using digital manipulation.

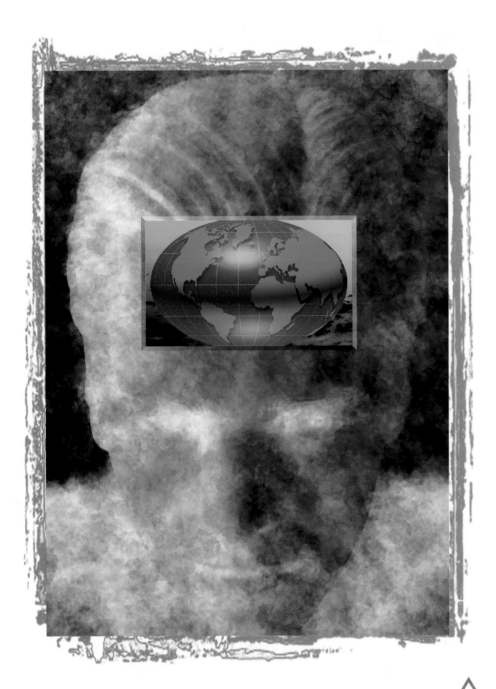

THINKING GLOBALLY

PHOTOGRAPHER
Tim Alt

DIGITAL CREATIVE
Tim Alt

SOFTWARE
**Adobe Photoshop, Strata
Studio Pro**

CATEGORY
Stock

TIM
ALT

Delving into the realm of dreams, this stock image by Tim Alt, explores the concept of thinking globally. In a unique twist, the man is represented as an element of nature; while the earth is pictured in abstract modern relief. Using the soft colors of space, the human figure blends into a darker surrounding cosmos. Windowed into the mind of the man, a brightly colored world map stands out in sharp contrast.

Filters and color reversing features in Xaos Filters were used to produce the texture and palette of the background figure. The saturated foreground elements were generated in Strata Studio Pro. The image was assembled and further enhanced using Adobe Photoshop.

This thoughtful design solution uses an equated reality to quietly explore and expand on a common phrase. It creates a mood, even as it raises questions. Alt's work often has a powerful high-tech look. In this more painterly example, he shows the diversity and impact of his talent.

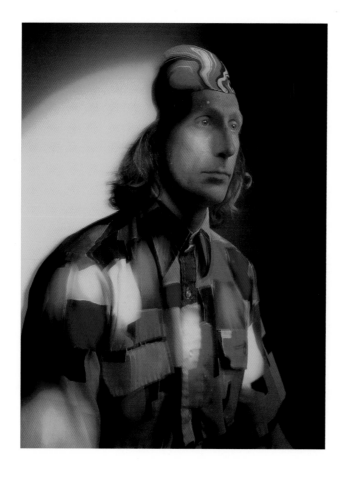

TODD

PHOTOGRAPHER
Stan Musilek

DIGITAL CREATIVE
Stan Musilek

CLIENT
Stan Musilek

SOFTWARE
Live Pictures

CATEGORY
Self-Promotion

DOGBOYS LOST IN THE CITY OF THE FUTURE

PHOTOGRAPHER
Ronald Dunlap

DIGITAL CREATIVE
Ronald Dunlap

CLIENT
Doglight Studios

SOFTWARE
Adobe Photoshop

CATEGORY
Promotion

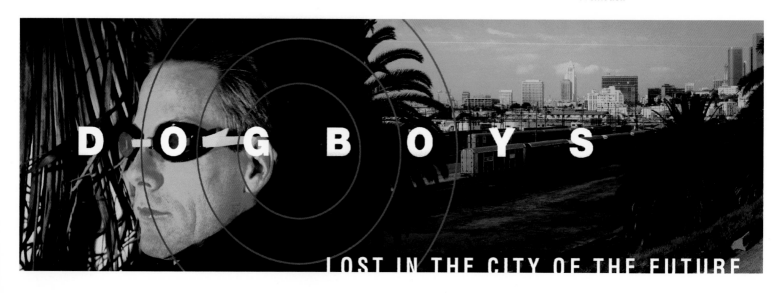

surreal

HEAD WITH BLUE TRIANGLES

PHOTOGRAPHER
Tim Alt

DIGITAL CREATIVE
Tim Alt

SOFTWARE
Adobe Photoshop

CATEGORY
Stock

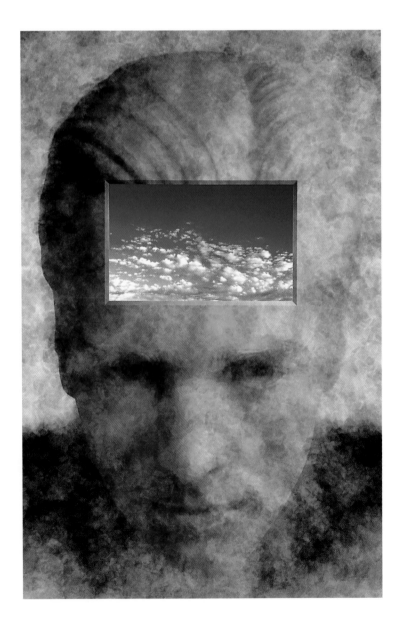

HEAD WITH CLOUDS

PHOTOGRAPHER
Tim Alt

DIGITAL CREATIVE
Tim Alt

SOFTWARE
Adobe Photoshop, Strata Studio
Pro

CATEGORY
Stock

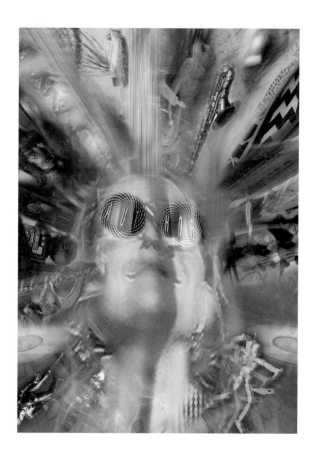

ACCESS HEAD

PHOTOGRAPHER & VIDEO
Lance Jackson

DIGITAL CREATIVE
**Clay James, Dahlin Smith &
White**

CLIENT
Sybase

SOFTWARE
Adobe Photoshop

CATEGORY
Advertising

LINE MAN

PHOTOGRAPHER
Rick Dunn

DIGITAL CREATIVE
Rick Dunn

CLIENT
Rick Dunn

SOFTWARE
Adobe Photoshop

CATEGORY
Promotion

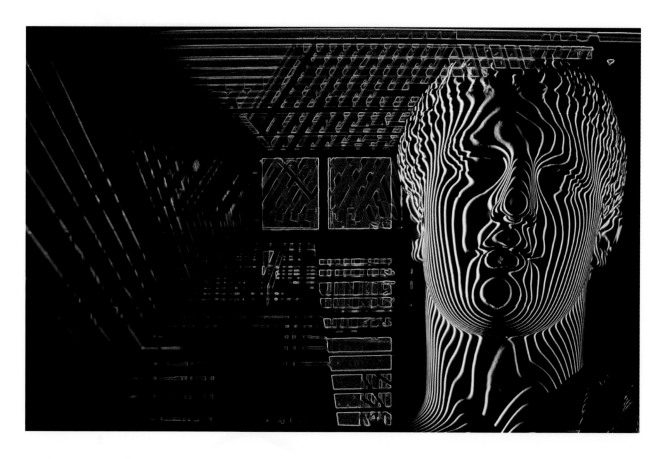

surreal

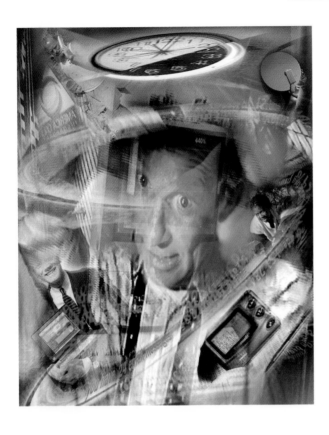

OVERWIRED

PHOTOGRAPHER & VIDEO
Lance Jackson, Craig Lee

DIGITAL CREATIVE
Kelly Frankeny

CLIENT
San Francisco Examiner

SOFTWARE
Adobe Photoshop

CATEGORY
Editorial

CEO

PHOTOGRAPHER & VIDEO
Susan McMullen, Lance Jackson, Craig Lee

DIGITAL CREATIVE
Greg Rattenborg/Bob Coontz Design

CLIENT
US West

SOFTWARE
Adobe Photoshop

CATEGORY
Conference Brochure

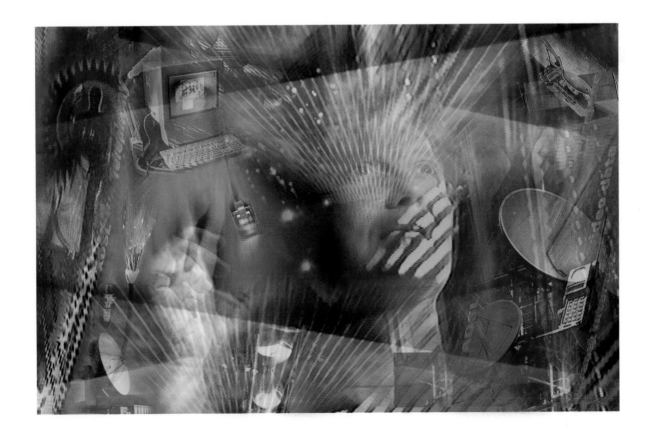

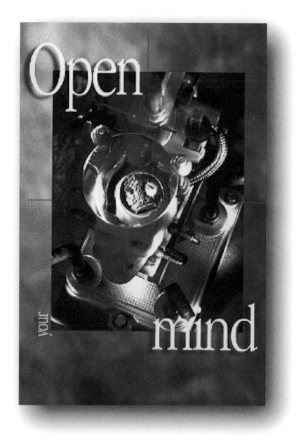

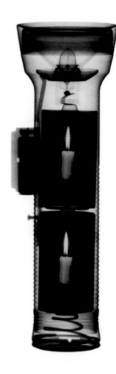

FLASHLIGHT

DIGITAL CREATIVE
Logan Seale

CLIENT
Logan Seale

SOFTWARE
Adobe Photoshop

CATEGORY
Editorial

E-BRAIN

PHOTOGRAPHER
Caesar Lima

DIGITAL CREATIVE
Caesar Lima

CLIENT
Promotion

SOFTWARE
Adobe Photoshop

CATEGORY
Promotional

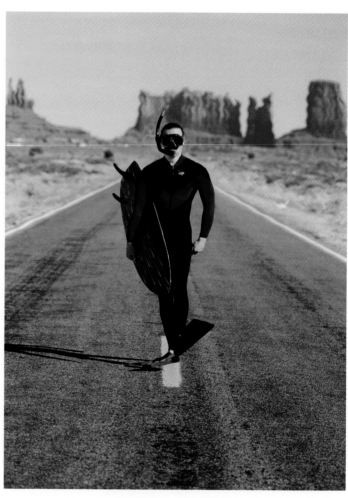

SCUBA MAN

PHOTOGRAPHER
Nick Koudis

DIGITAL CREATIVE
Koudis Nick

CLIENT

SOFTWARE
Adobe Photoshop

CATEGORY
Advertising

surreal

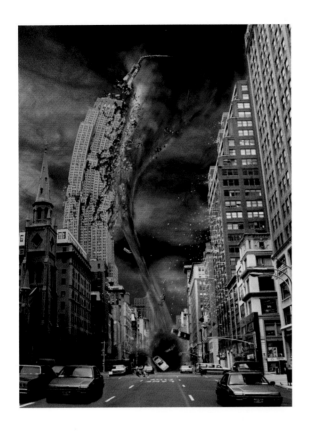

NEW YORK TWISTER

PHOTOGRAPHER
Barry Blackman

DIGITAL CREATIVE
Barry Blackman

CLIENT
Portal Publications

SOFTWARE
Barco Creator

CATEGORY
Poster

FUTURE HOUSE

PHOTOGRAPHER
Ed Lowe

DIGITAL CREATIVE
Philip Howe

CLIENT
Ziff/Davis

SOFTWARE
**Adobe Photoshop,
Fractal Design's Painter**

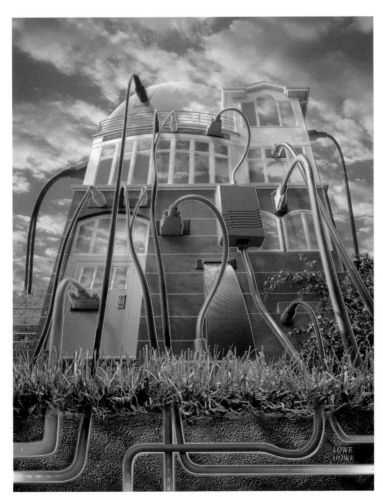

SKELETON HAND

PHOTOGRAPHER
Tom Collicott

DIGITAL CREATIVE
Tom Collicott

CLIENT
Word Perfect Magazine

SOFTWARE
Adobe Photoshop

CATEGORY
Editorial

HYPOCRATIC OATH

PHOTOGRAPHER
Scott Ferguson

DIGITAL CREATIVE
Scott Ferguson

ART DIRECTOR
Richard Boddy

CLIENT
Discover Magazine

SOFTWARE
Live Picture, Fractal Design's
Painter, Adobe Illustrator,
Adobe Photoshop

CATEGORY
Editorial

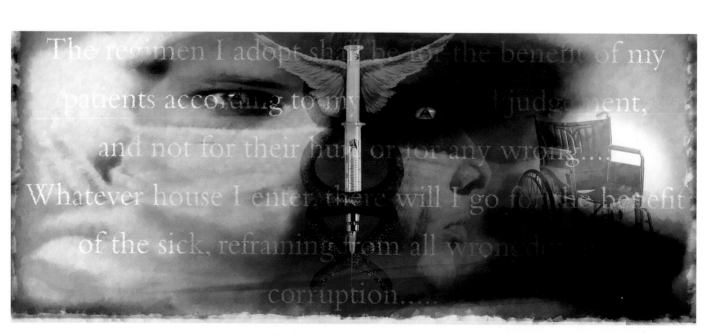

The regimen I adopt shall be for the benefit of my patients according to my ability and judgement, and not for their hurt or for any wrong.... Whatever house I enter, there will I go for the benefit of the sick, refraining from all wrong doing or corruption.....

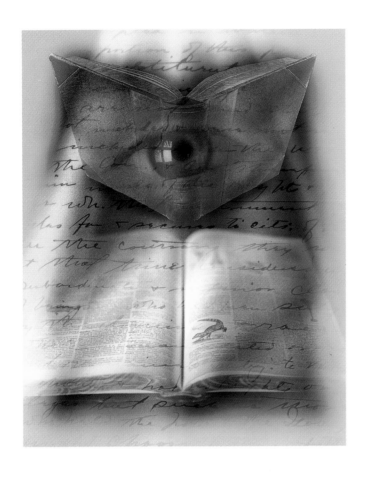

BOOK/EYE

PHOTOGRAPHER
Tom Collicott

DIGITAL CREATIVE
Tom Collicott

CLIENT
Word Perfect Magazine

SOFTWARE
Adobe Photoshop

CATEGORY
Editorial

LOBOTOMY

PHOTOGRAPHER
Scott Ferguson

DIGITAL CREATIVE
Scott Ferguson

ART DIRECTOR
Richard Boddy

CLIENT
Discover Magazine

SOFTWARE
Live Picture, Fractal Design's Painter,
Adobe Illustrator, Adobe Photoshop

CATEGORY
Editorial

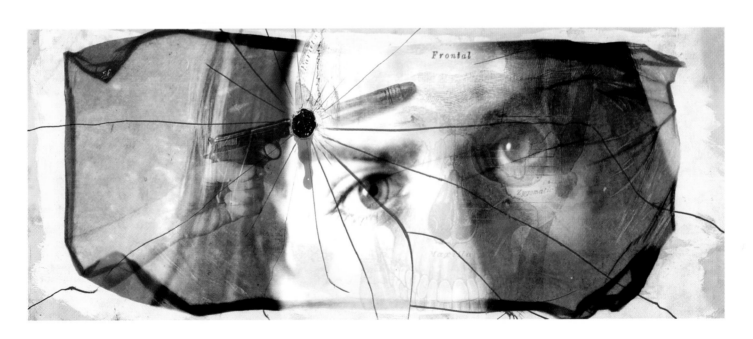

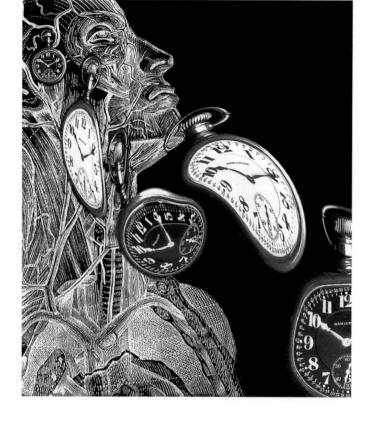

FIGURE WITH TIMEPIECES

PHOTOGRAPHER
David Chalk

DIGITAL CREATIVE
David Chalk

CLIENT
William Morrow & Co.

SOFTWARE
Barco Creator

CATEGORY
Experimental

LOVE HARP

PHOTOGRAPHER
Stock

DIGITAL CREATIVE
Eric Berendt

CLIENT
Promotion

SOFTWARE
Adobe Photoshop

CATEGORY
Promotion

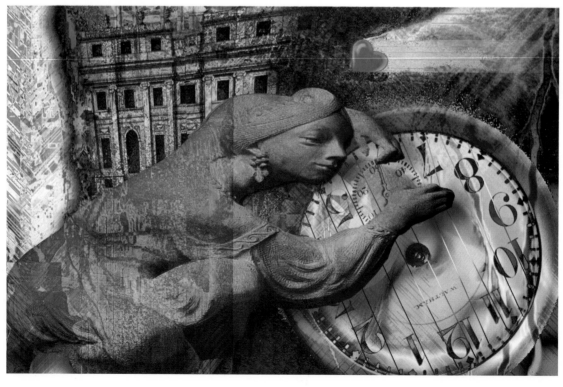

surreal

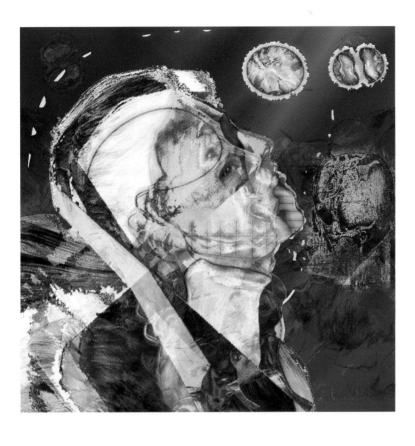

ALIEN ARRIVAL

PHOTOGRAPHER
Stock

DIGITAL CREATIVE
Eric Berendt

CLIENT
Promotion

SOFTWARE
Adobe Photoshop

CATEGORY
Promotion

KLEE TRIUMPHS OVER THE CREATIONISTS

PHOTOGRAPHER
Stock

DIGITAL CREATIVE
Eric Berendt

CLIENT
Promotion

SOFTWARE
Adobe Photoshop

CATEGORY
Promotion

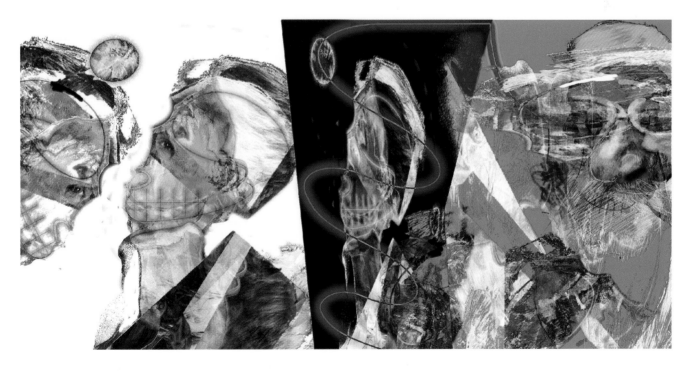

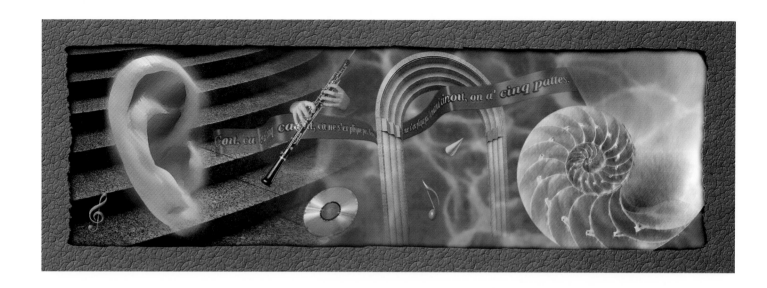

SOUND	**SENSES**
PHOTOGRAPHER	*PHOTOGRAPHER*
J.W. Burkey	J.W. Burkey
DIGITAL CREATIVE	*DIGITAL CREATIVE*
J.W. Burkey	J.W. Burkey
CLIENT	*CLIENT*
Stock Image	Stock Image
SOFTWARE	*SOFTWARE*
Live Picture, Adobe Photoshop	Adobe Photoshop
CATEGORY	*CATEGORY*
Stock	Stock

surreal

THE ARCHITECT

PHOTOGRAPHER
Rick Dunn

DIGITAL CREATIVE
Rick Dunn

CLIENT
Rick Dunn

SOFTWARE
Adobe Photoshop, Fractal Design's Painter

CATEGORY
Promotion

DISCOVERY

PHOTOGRAPHER
Rick Dunn

DIGITAL CREATIVE
Rick Dunn

CLIENT
Rick Dunn

SOFTWARE
Adobe Photoshop, Strada 3D

CATEGORY
Promotion

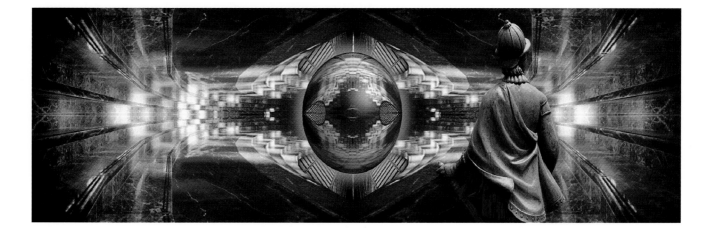

HEAD GRID

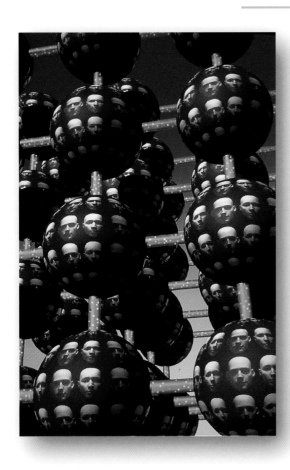

PHOTOGRAPHER
Tim Alt

DIGITAL CREATIVE
Tim Alt

SOFTWARE
Strata 3D, Adobe Photoshop

CATEGORY
Stock

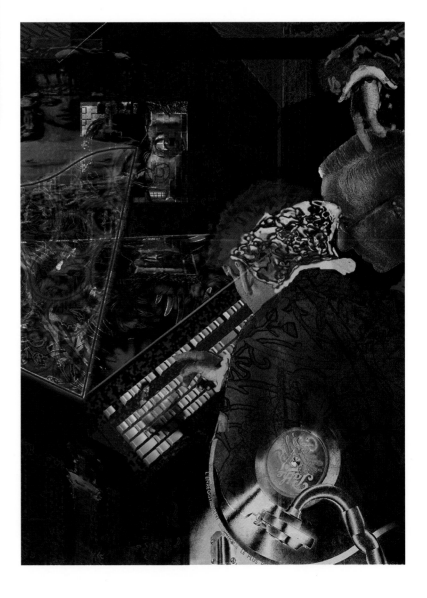

PATHÉ

PHOTOGRAPHER
Stock

DIGITAL CREATIVE
Eric Berendt

CLIENT
Promotion

SOFTWARE
Adobe Photoshop,
Ray Dream Designer

CATEGORY
Promotion

SURREAL surreal

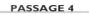

PASSAGE 4

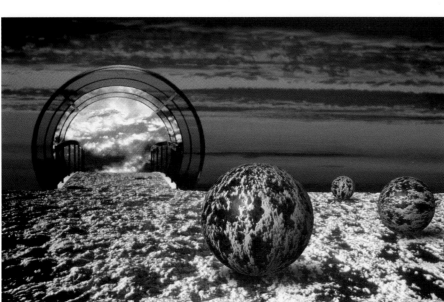

PHOTOGRAPHER
Rick Dunn

DIGITAL CREATIVE
Rick Dunn

CLIENT
Rick Dunn

SOFTWARE
Adobe Photoshop, Strada 3D

CATEGORY
Promotion

FLAME HAND; NOUMENA LOGO

DIGITAL CREATIVE
Rob Magiera

CLIENT
Personal, Company Logo

SOFTWARE
Adobe Photoshop, Alias Sketch!

CATEGORY
Self Promotion

SUICIDE

PHOTOGRAPHER
Scott Ferguson

DIGITAL CREATIVE
Scott Ferguson

ART DIRECTOR
Richard Boddy

CLIENT
Discover Magazine

SOFTWARE
Live Picture, Fractal Design's Painter,
Adobe Illustrator, Adobe Photoshop

CATEGORY
Editorial

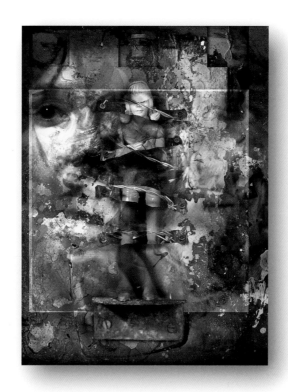

BRAIN BOY

PHOTOGRAPHER
Erik Ostling

DIGITAL CREATIVE
Rob Magiera

CLIENT
Novell

SOFTWARE
Adobe Photoshop,
Alias Sketch!

CATEGORY
Advertising

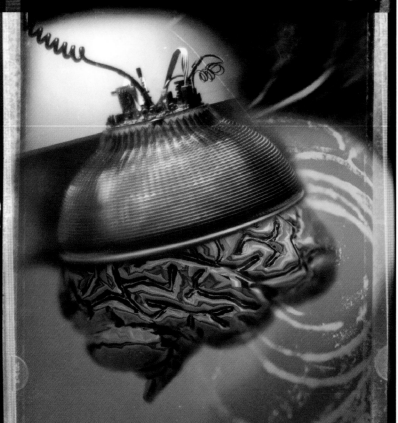

SURREAL *surreal*

MNEMONIC

ILLUSTRATOR
Jeff Brice

ART DIRECTOR
John Plunkett

CLIENT
Wired Magazine

SOFTWARE
Adobe Photoshop

CATEGORY
Editorial

MNEMONIC

ILLUSTRATOR
Jeff Brice

ART DIRECTOR
John Plunkett

CLIENT
Wired Magazine

SOFTWARE
Adobe Photoshop

CATEGORY
Editorial

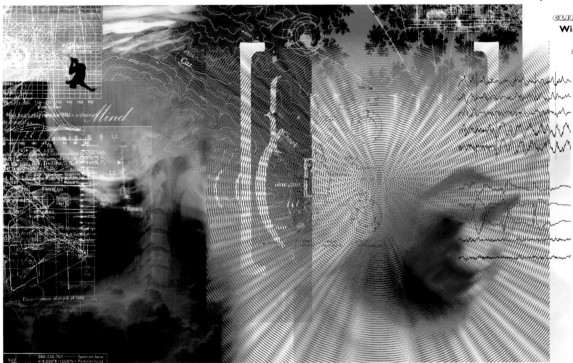

editorial

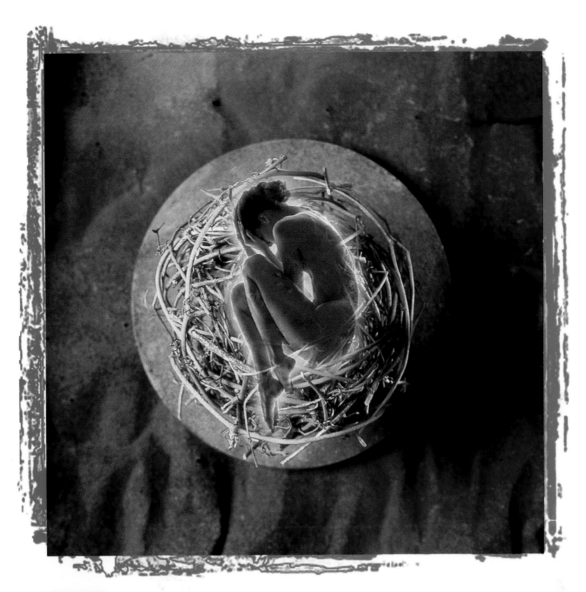

WHITE/
PACKERT

These emotional images were created for *MIT Technology Review* to illustrate the natural immunity of some people who have been minimally exposed to the AIDS virus. Within the design solution, White/Packert captures both human vulnerability and the concept of protective environments. A male and female figure, shown in fragile posture, are placed in the safety of a nest and a secure metal ball.

The various photographic elements of the images were assembled and layered in Adobe Photoshop using masking and filters to create the dramatic effect. The vivid colors were achieved in Live Picture to enhance the tension and sense of contrast between danger and security.

White/Packert's thoughtful approach conveys the critical relationship between science and the human experience. The rich visual language elaborates the complexity and deep concern of a difficult and griping subject. The strength of this work lies in their ability to identify and develop strong elements and to effectively combine and enhance them.

MALE AND FEMALE COCOON

PHOTOGRAPHERS
Sharon White/Bob Packert

DIGITAL CREATIVES
Sharon White/Bob Packert

CLIENT
MIT Technology Review

SOFTWARE
Adobe Photoshop, Live Picture

CATEGORY
Editorial

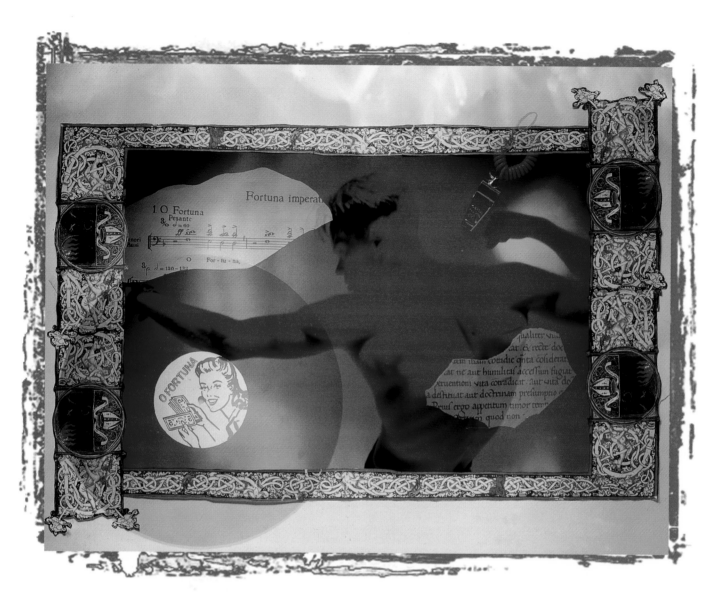

KEN DAVIES

This intriguing tableau, which explores the historical roots of a modern dance record, was created to illustrate a feature article for *Toronto Life Magazine*. It combines elements representing the album called *Oh Fortuna* (the classical work upon which it was based) and the medieval poem that inspired the music. Anchoring these details is the central image of Fortuna, the ancient Roman goddess of good fortune.

Original photographs of the figure and the album were imported into Adobe Photoshop. Scans of torn pieces of sheet music and a section of the ancient poem were positioned around the torso. The elements were then assembled as a collage using varied degrees of opacity and a concentrated, monochromatic set of color values.

An ornate border of the image confines the tension of the figure and makes a connection between past and present. The record overlaps the border and begins to escape the boundaries of historical time. Ken Davies' work is both powerful and intense. This stylized example is typical of his effective visual approach.

OH FORTUNA

PHOTOGRAPHER
Ken Davies

DIGITAL CREATIVE
Ken Davies

CLIENT
Toronto Life Magazine

SOFTWARE
Adobe Photoshop

CATEGORY
Editorial

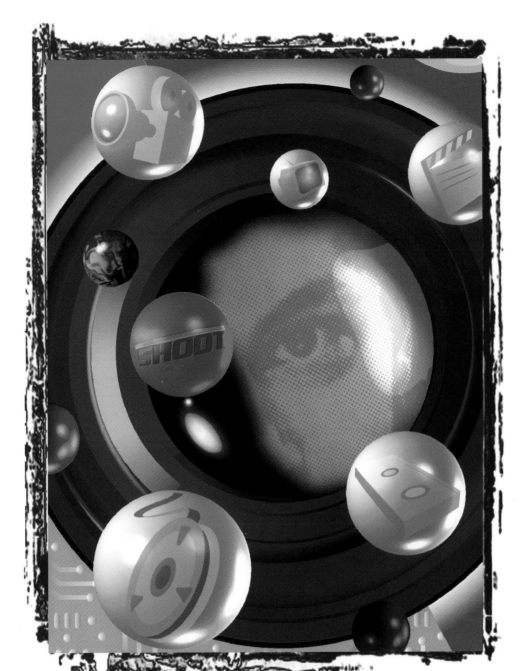

JAVIER
ROMERO

Designed for *Shoot Magazine's* media kit folder cover, this image dynamically conveys the attitude of the publisher. The eye, peering through the lens, captures and records the moving spheres of media. The colorful intersection of components give the design a contemporary, high energy feeling.

The photographic elements were imported into Adobe Photoshop. A high contrast filter was applied to the face to give it a more graphic feel and the colorful spheres were generated. The Shoot logo was imported into Adobe Illustrator and warped to conform to a spherical shape. Movie camera and other media icons were also created in Illustrator. The composition was assembled in Photoshop. Light reflections and the vividly colorful palette were added, creating a sense of depth and action.

For over a decade, Javier Romero Design Group has been helping companies involved in the creative process develop unique and compelling messages for advertising, publishing and media. With studios in New York and Madrid, they bridge the gap between creativity and technology through understanding, experience and innovative thinking.

SHOOT MAGAZINE

DIGITAL CREATIVE
JRDG

CLIENT
Shoot Magazine

SOFTWARE
**Adobe Illustrator,
Adobe Photoshop**

CATEGORY
Media Kit

EDITORIAL

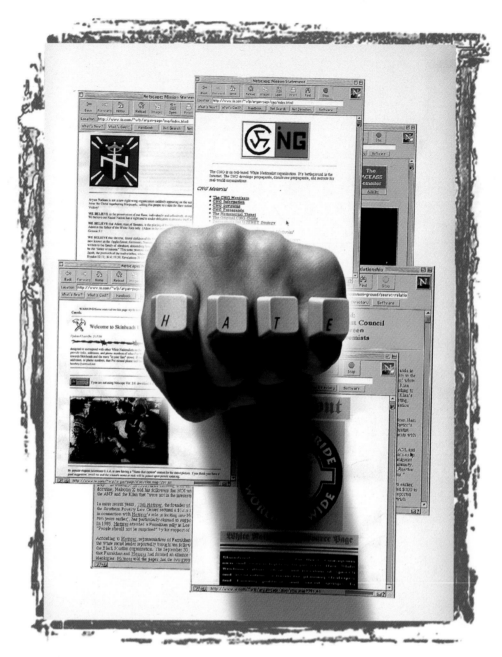

MIRKO ILIĆ

CYBERHATE

PHOTOGRAPHERS
Maria Vullo, Tabanitha T. McDaniel

DIGITAL CREATIVE
Mirko Ilić

CLIENT
Emerge Magazine

SOFTWARE
Adobe Photoshop

CATEGORY
Editorial

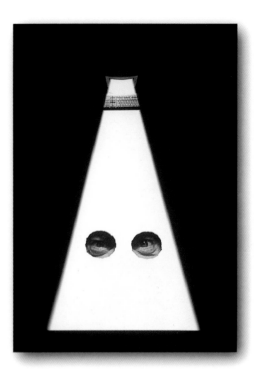

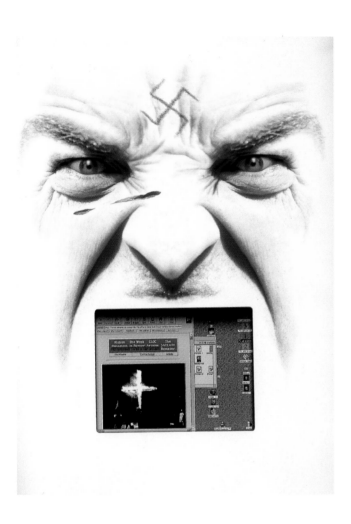

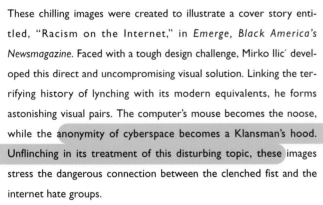

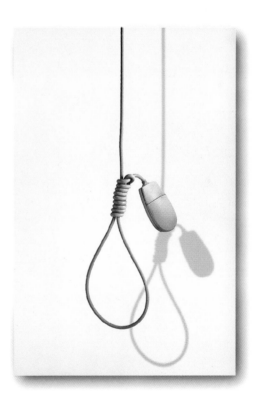

These chilling images were created to illustrate a cover story entitled, "Racism on the Internet," in *Emerge, Black America's Newsmagazine*. Faced with a tough design challenge, Mirko Ilic´ developed this direct and uncompromising visual solution. Linking the terrifying history of lynching with its modern equivalents, he forms astonishing visual pairs. The computer's mouse becomes the noose, while the anonymity of cyberspace becomes a Klansman's hood. Unflinching in its treatment of this disturbing topic, these images stress the dangerous connection between the clenched fist and the internet hate groups.

Working in Adobe Photoshop, objects and graphic elements are linked with precise control, resulting in a clear, high-impact message. Shadows, contrast, and exaggerated highlights all add emphasis to the work. Actual hate group web pages form a visual and factual background that accentuates the sinister reality of the theme. Ilic´'s powerful design solutions profoundly impact on the consciousness of the reader. His work unmasks the truth with convincing portraits of human circumstance.

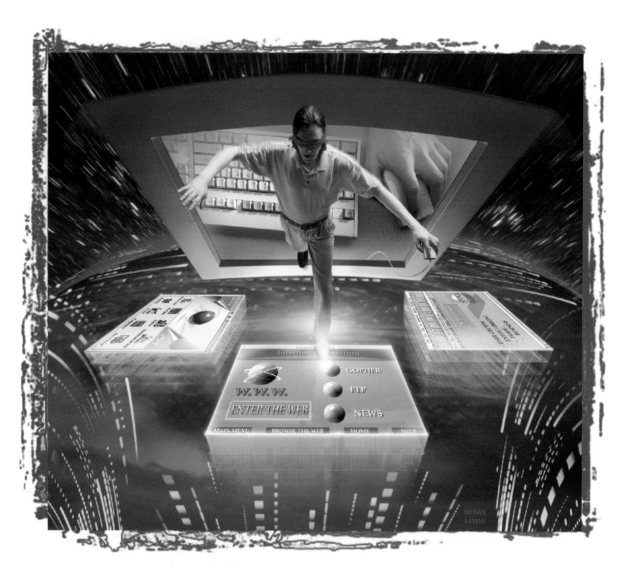

PHIL HOWE

NET WALK

PHOTOGRAPHER
Ed Lowe

DIGITAL CREATIVE
Philip Howe

CLIENT
Ziff/Davis Publishing

SOFTWARE
Adobe Photoshop

CATEGORY
Editorial

Asked to show the precarious moment when a person first enters the Internet, Phil Howe created this energetic and amusing image. He juxtaposed the fast-paced excitement of stepping into cyberspace, with the tentative balance of blind uncertainty. The design is linked to reality by the hand controlling the mouse. The arms of the figure are reaching for stability, as zips and dashes of data race through net space.

Howe developed a pencil layout and worked with photographer Ed Lowe to create a set of well-matched photographic images. The components were scanned and assembled in Adobe Photoshop. To create the playful sense of tension between reality and illusion, the image was carefully layered, painted, distorted and enhanced. The final result is a concise, easily interpreted illustration.

With more than twenty years of experience as an illustrator and a strong photo-retouching background, he integrates his work with a wide variety of digital manipulation techniques. Howe's clear and creative visual solutions demonstrate his enjoyment in meeting the design needs of the client.

WELCOME TO CYBERSPACE

DIGITAL CREATIVES
Mirko Ilic´, Alex Arce

CLIENT
Time Magazine

SOFTWARE
Soft Image, Adobe Photoshop

CATEGORY
Editorial

CUTTING THE CORD

PHOTOGRAPHER
Mike Fizer

DIGITAL CREATIVE
Henk Dawson

CLIENT
Home Mechanix

SOFTWARE
Studio Pro, Adobe Photoshop

CATEGORY
Editorial

129

PARTICIPATION

PHOTOGRAPHER
Bob Schlowsky, Stock Images

DIGITAL CREATIVE
Lois Schlowsky

CLIENT
Moore Business Forms

SOFTWARE
QFX, Adobe Photoshop

CATEGORY
Magazine Cover

4 MOUSE CONTROLS WITH GLOBE IMAGE

PHOTOGRAPHER
Ken Davies

DIGITAL CREATIVE
Ken Davies

CLIENT
Family PC Magazine

SOFTWARE
Adobe Photoshop

CATEGORY
Editorial

editorial EDITORIAL

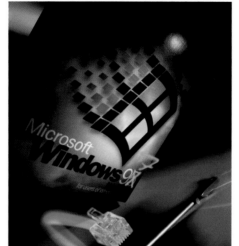

WINDOWS '97

PHOTOGRAPHER
Logan Seale

DIGITAL CREATIVE
Logan Seale

ART DIRECTOR
Doug Adams

CLIENT
Windows Magazine

SOFTWARE
Adobe Photoshop

CATEGORY
Editorial

INTERNAL FEATURE

PHOTOGRAPHER
Bill Milne

DIGITAL CREATIVE
Bill Milne

CLIENT
Lan Times Magazine

SOFTWARE
Adobe Photoshop, Adobe Illustrator

CATEGORY
Editorial

THE FUTURE OF OPHTHALMOLOGY

PHOTOGRAPHER
Dan Marcolina

DIGITAL CREATIVE
Dan Marcolina, Stock

CLIENT
Chilton Publishing

SOFTWARE
Adobe Photoshop, Specular Collage

CATEGORY
Editorial/Medical

KEYBOARD/SKULL/PIPE

PHOTOGRAPHER
Tom Collicott

DIGITAL CREATIVE
Tom Collicott

CLIENT
Internet Underground Magazine

SOFTWARE
Adobe Photoshop

CATEGORY
Editorial

W.W.W.

DIGITAL CREATIVE
Eric Yang

CLIENT
Computer Shopper Magazine

SOFTWARE
Adobe Photoshop

CATEGORY
Editorial

JEEP

DIGITAL CREATIVE
Eric Yang

CLIENT
Popular Science Magazine

SOFTWARE
Adobe Photoshop

CATEGORY
Editorial

editorial EDITORIAL

SPEAKER INSTALLATION

DIGITAL CREATIVE
Eric Yang

CLIENT
Car Stereo Review Magazine

SOFTWARE
Adobe Photoshop

CATEGORY
Editorial

CD INSTALLATION

DIGITAL CREATIVE
Eric Yang

CLIENT
Car Stereo Review Magazine

SOFTWARE
Adobe Photoshop

CATEGORY
Editorial

CAN JUSTICE BE DONE?

PHOTOGRAPHER
Mirko Ilić, Stock Photography

DIGITAL CREATIVE
Mirko Ilić

CLIENT
World Press Review

SOFTWARE
Adobe Photoshop

CATEGORY
Editorial

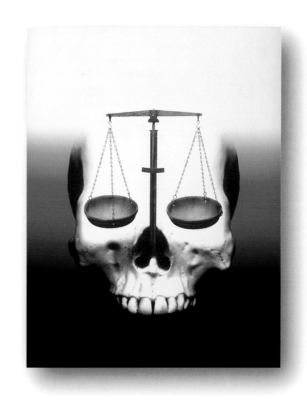

THE FIRST INTERACTIVE MUSEUM

PHOTOGRAPHER
Mirko Ilić,
Stock Photography

DIGITAL CREATIVE
Mirko Ilić

CLIENT
Swing Magazine

SOFTWARE
Adobe Photoshop

CATEGORY
Editorial

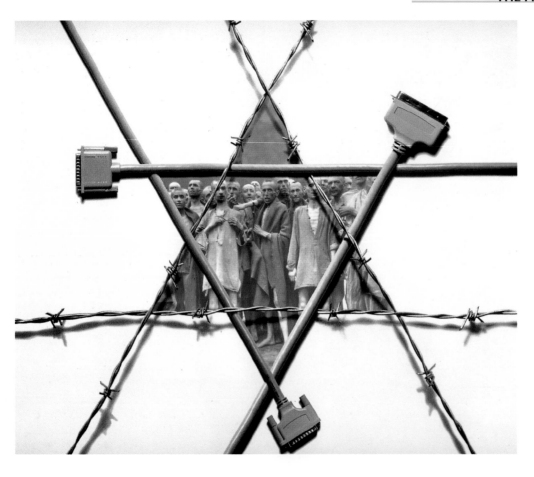

editorial EDITORIAL

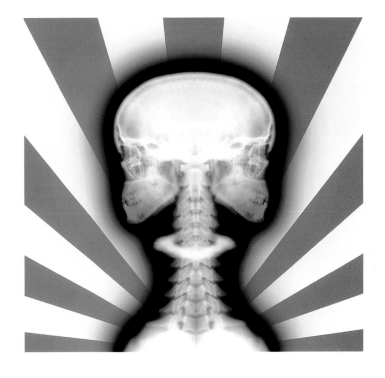

HIROSHIMA LEGACY

DIGITAL CREATIVE
Mirko Ilić

CLIENT
New York Times Book Review

SOFTWARE
Adobe Photoshop,
Adobe Illustrator

CATEGORY
Editorial

C.I.A.

PHOTOGRAPHER
Maria Vullo

DIGITAL CREATIVE
Mirko Ilić

CLIENT
Emerge Magazine

SOFTWARE
Adobe Photoshop, Adobe Illustrator

CATEGORY
Editorial

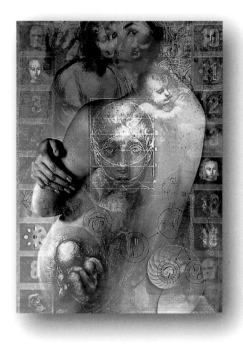

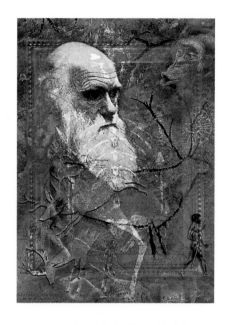

DARWINIAN MEDICINE

PHOTOGRAPHER
Scott Ferguson

DIGITAL CREATIVE
Scott Ferguson

ART DIRECTOR
Richard Boddy

CLIENT
Discover Magazine

SOFTWARE
Live Picture, Fractal
Design's Painter,
Adobe Illustrator,
Adobe Photoshop

CATEGORY
Editorial

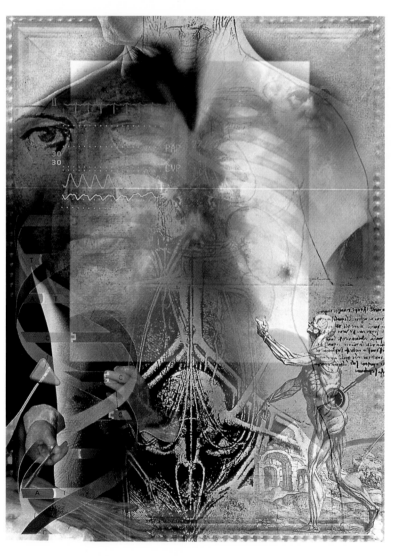

editorial EDITORIAL

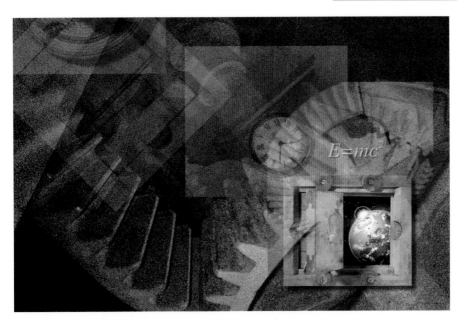

HIGHER LEARNING EDUCATION

PHOTOGRAPHER
Bill Milne

DIGITAL CREATIVE
Bill Milne

CLIENT
Sterling Publishing

SOFTWARE
Adobe Photoshop

CATEGORY
Book Cover

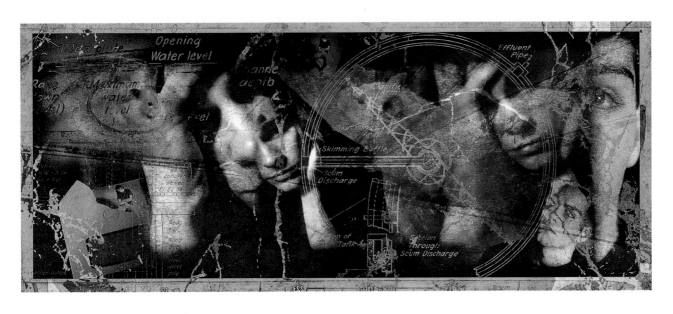

SCHIZOPHRENIA

PHOTOGRAPHER
Scott Ferguson

DIGITAL CREATIVE
Scott Ferguson

ART DIRECTOR
Richard Boddy

CLIENT
Discover Magazine

SOFTWARE
**Live Picture, Fractal Design's
Painter, Adobe Illustrator,
Adobe Photoshop**

CATEGORY
Editorial

THE FUTURE OF CHECKING

PHOTOGRAPHER
William Whitehurst

DIGITAL CREATIVE
William Whitehurst

CLIENT
ABA Banking Journal

SOFTWARE
Adobe Photoshop, Live Picture

CATEGORY
Editorial

MULTIMEDIA COSTS

PHOTOGRAPHER
Joseph Kelter

DIGITAL CREATIVE
BadCat Design, Inc.

CLIENT
Upside Publishing

SOFTWARE
**Specular Collage, Infini-D,
Adobe Photoshop**

CATEGORY
Editorial

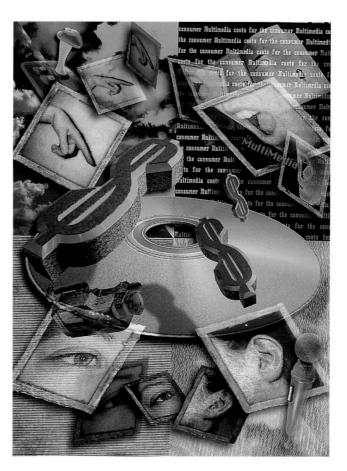

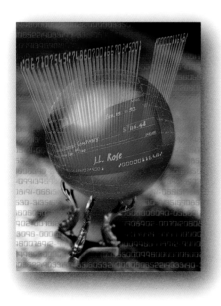

SOFTWARE RIPS

PHOTOGRAPHER
Joseph Kelter

DIGITAL CREATIVE
BadCat Design, Inc.

CLIENT
Publish Magazine

SOFTWARE
**Specular Collage, Infini-D,
Adobe Photoshop**

CATEGORY
Editorial

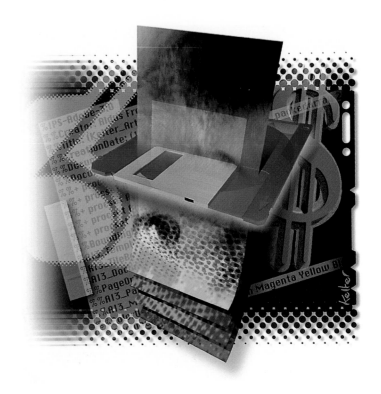

editorial EDITORIAL

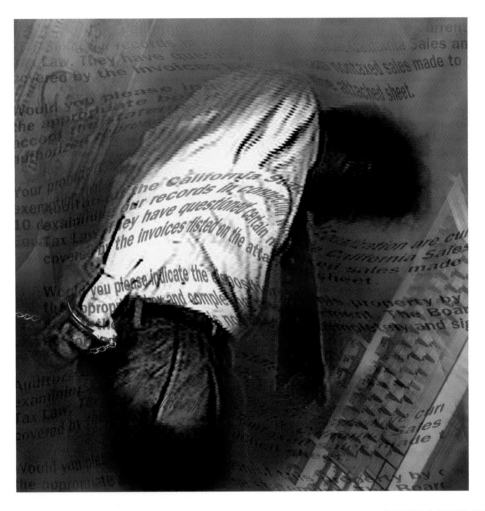

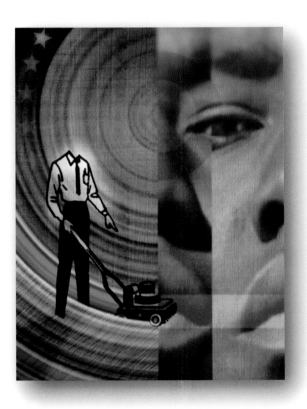

DIGITAL TIME. BUSTED

PHOTOGRAPHY & VIDEO
Susan McMullen

DIGITAL CREATIVE
Lisa Webber

CLIENT
IBM

SOFTWARE
Adobe Photoshop

CATEGORY
Editorial

POP AMERICAN LAWNS

PHOTOGRAPHER
Steve Mungay

DIGITAL CREATIVE
Paul Watson

CLIENT
Precision Craft

SOFTWARE
Adobe Photoshop

CATEGORY
E-Zine

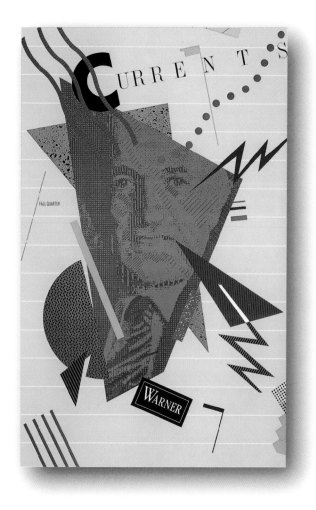

CURRENT

DIGITAL CREATIVE
JRDG

CLIENT
Warner Communications

SOFTWARE
Mac Paint

CATEGORY
Quarterly Report Cover

BUGS

DIGITAL CREATIVE
Eric Berendt

CLIENT
Compuserve Magazine

SOFTWARE
Adobe Photoshop,
Adobe Illustrator

CATEGORY
Editorial

editorial EDITORIAL

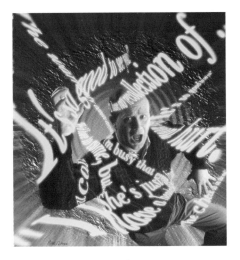

IMAGINATION/KNOWLEDGE

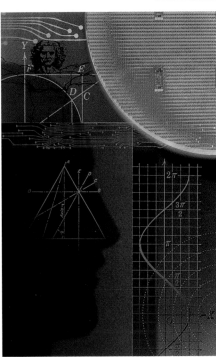

PHOTOGRAPHER
Steven Hunt

DIGITAL CREATIVE
Steven Hunt

CLIENT
CRC Press

SOFTWARE
Adobe Photoshop

CATEGORY
Book Cover/Text

WRAPPED UP IN LIES

PHOTOGRAPHER
Ed Lowe

DIGITAL CREATIVE
Philip Howe

ART DIRECTOR
Dianne Bartley

CLIENT
Kiwanis

SOFTWARE
Adobe Photoshop,
Fractal Design's Painter

CATEGORY
Editorial

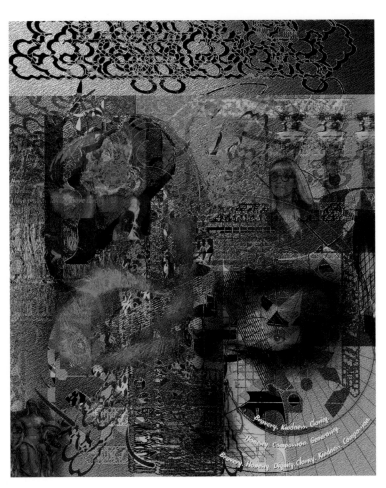

FORGETTING

PHOTOGRAPHER
Stock

DIGITAL CREATIVE
Eric Berendt

CLIENT
Promotion

SOFTWARE
Adobe Photoshop,
Adobe Illustrator

CATEGORY
Editorial

PC I

ILLUSTRATOR
Jeff Brice

ART DIRECTOR
Joanne Hoffman

CLIENT
MacWorld Magazine

SOFTWARE
Adobe Photoshop

CATEGORY
Editorial

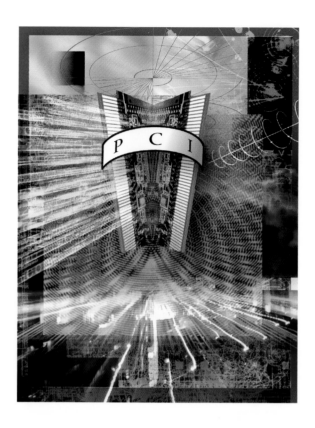

WIDE WORLD WEBBERS

PHOTOGRAPHY & VIDEO
Lance Jackson

DIGITAL CREATIVE
Misiak

CLIENT
Compuserve Magazine

SOFTWARE
Adobe Photoshop

CATEGORY
Editorial

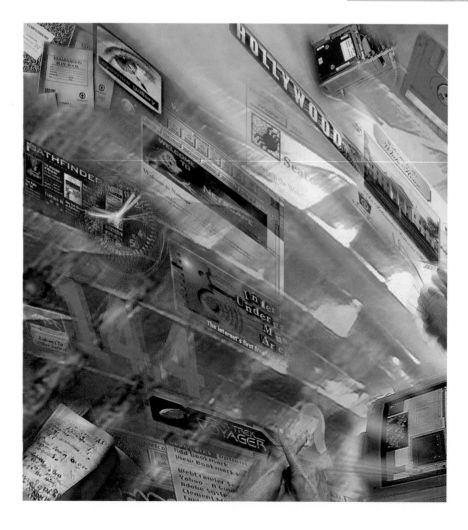

editorial EDITORIAL

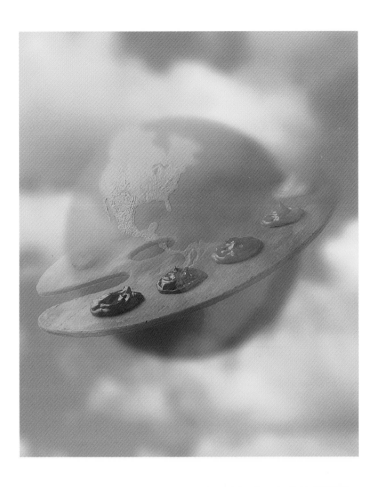

GLOBE/PALETTE

PHOTOGRAPHER
Tom Collicott

DIGITAL CREATIVE
Tom Collicott

CLIENT
Moody Magazine

SOFTWARE
Adobe Photoshop

CATEGORY
Editorial

HOURGLASS

PHOTOGRAPHER
Logan Seale

DIGITAL CREATIVE
Logan Seale

CLIENT
Logan Seale

SOFTWARE
Adobe Photoshop,
Photo Edges

CATEGORY
Editorial

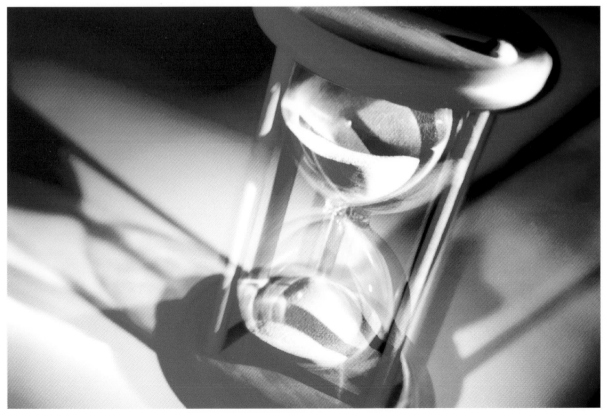

AROMATHERAPHY BOOK

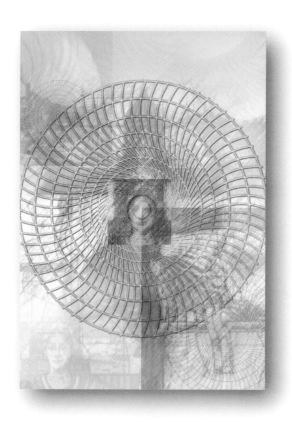

PHOTOGRAPHER
Bill Milne

DIGITAL CREATIVE
Bill Milne

CLIENT
Sterling Publishing

SOFTWARE
Adobe Photoshop, Adobe Illustrator

CATEGORY
Book Design

SOCIAL TRIANGLES

PHOTOGRAPHER
Paul Watson

DIGITAL CREATIVE
Paul Watson

CLIENT
Nelson Canada

SOFTWARE
Adobe Photoshop

CATEGORY
Book Cover

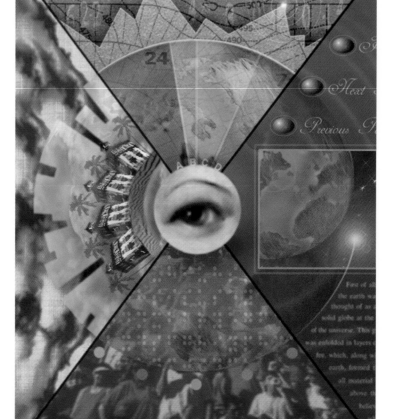

editorial EDITORIAL

ORBUS TERRARUM

PHOTOGRAPHER
Paul Watson

DIGITAL CREATIVE
Paul Watson

CLIENT
Request Magazine

SOFTWARE
Adobe Photoshop

CATEGORY
Music Magazine

3.0

ILLUSTRATOR
Jeff Brice

ART DIRECTOR
Joanne Hoffman

CLIENT
MacWorld Magazine

SOFTWARE
Adobe Photoshop

CATEGORY
Editorial

MIRACLE MEDICINE

PHOTOGRAPHER
Steven Hunt

DIGITAL CREATIVE
Steven Hunt

CLIENT
PWS Publishing

SOFTWARE
Adobe Photoshop

CATEGORY
Editorial

COVER DESIGN

PHOTOGRAPHER
Bill Milne

DIGITAL CREATIVE
Bill Milne

CLIENT
Sterling Publishing

SOFTWARE
Adobe Photoshop,
Adobe Illustrator

CATEGORY
Hardcover Book Design

BLUE EYE

PHOTOGRAPHER
Logan Seale

DIGITAL CREATIVE
Logan Seale

CLIENT
Logan Seale

SOFTWARE
Adobe Photoshop

CATEGORY
Editorial

editorial EDITORIAL

BIOMETRICS

PHOTOGRAPHER
William Whitehurst

DIGITAL CREATIVE
William Whitehurst

CLIENT
ABA Banking Journal

SOFTWARE
Adobe Photoshop, Live Picture

CATEGORY
Editorial

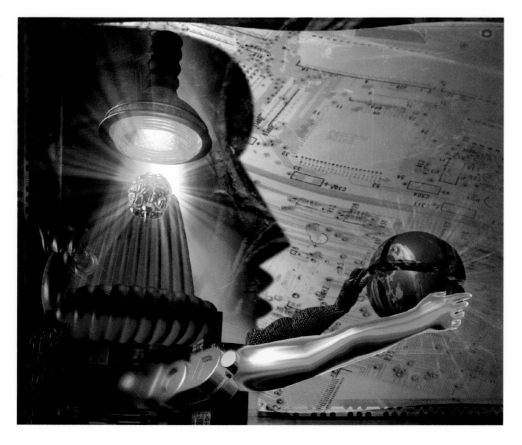

SYNTHETIC SENTIENCE

DIGITAL CREATIVE
Rob Magiera

CLIENT
Mondo 2000

SOFTWARE
**Adobe Photoshop,
Alias Power Animator**

CATEGORY
Editorial

promotional

STAN
MUSILEK

RAT RACE

PHOTOGRAPHER
Stan Musilek

DIGITAL CREATIVE
Stan Musilek

CLIENT
Stan Musilek

SOFTWARE
Live Pictures

CATEGORY
Promotion

The power of this image lies in its universally understood representation of human entrapment in an unending cycle of sameness. Originally designed as a self-promotion by Stan Musilek, depicting the unrealistic belief that everyone can achieve the American dream, this starkly provoking representation was later used with the image of a caged woman to advertise an anti-depressant.

The hamster wheel and the man were photographed against the same background and scanned into Adobe Photoshop. The integration of the elements was achieved using Live Picture, and the final composition was completed in Photoshop. Filters were then implemented to create the feeling of motion, enhanced lighting and a dramatically altered palette of color.

Musilek Photography has been producing compelling images for more than eighteen years. The advent of digital technology has expanded the range of their work and has given them the creative power to produce images that surpass time and space. Their contemporary vision has brought a wide range of large corporate clients including both Apple and Microsoft.

MATTHEW PEACOCK

Anonymous Productions was given the challenge of developing a concise, visual identity for a newly formed recording company called Safehouse. By sampling the musical styles represented on the label, Matt Peacock transforms a futuristic and experimental sound into a striking graphic image that balances the brightly modern with the darkly industrial.

After the composition was developed on paper, it was scanned into Adobe Photoshop and used as a framework for the final piece. A stock image of a gas mask was imported into the program and integrated into the design. The text elements were produced in Adobe Illustrator and then saved as outlines. This step allowed for efficient manipulation and adjustments. The intense color palette and the final high resolution was completed in Adobe Photoshop.

Anonymous Productions is a fully digital design studio that specializes in cutting-edge visual applications. They work to create clearly focused imagery that reveals the client's true identity. With flexibility and insight, they find the perfect solutions for print, online and interactive multimedia projects.

DIGITAL CREATIVE
Matthew Peacock
Anonymous Productions

CLIENT
Safehouse Records

SOFTWARE
Adobe Photoshop,
Adobe Illustrator

CATEGORY
Business

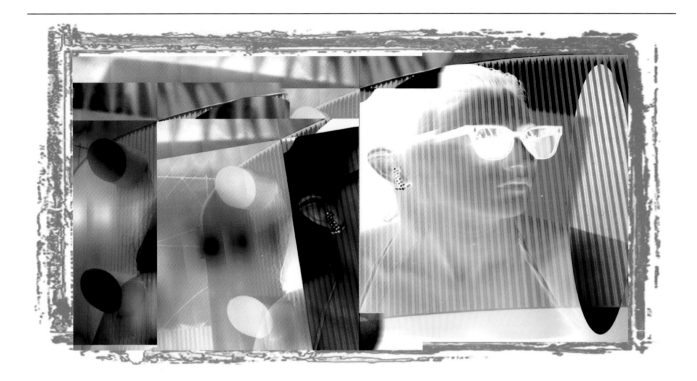

RONALD DUNLAP

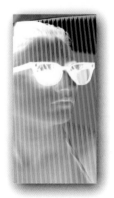

In this promotional spread by Ronald Dunlap, the repetition of pattern and soft colors captures a mood of warmth and mystery. Serving as an opening portrait in an actress' portfolio, the multiple image hints at her versatility in changing roles. The overlapping quality obscures detail and background information, and allows the viewer to conjecture thoughts about the woman behind the glasses. Her chameleon-like nature is further emphasized in the distinctly varied shades of her portrait.

Panoramic photographs were collaged several times, and adjusted in Adobe Photoshop using filters and color effects. Image reversing was applied to the original pictures. The elements were manipulated many times and a new coloration was added.

In this bizarre approach, Dunlap has taken the traditional headshot in a new direction. By concealing rather then revealing, power and excitement are established. Bringing a surreal exuberance and panoramic vision to his images, Dunlap demonstrates his own playful symbolism and shares the magical vision of his wide-ranging work.

SHADE

PHOTOGRAPHER
Ronald Dunlap

DIGITAL CREATIVE
Ronald Dunlap

CLIENT
Shaylee Dunn

SOFTWARE
Adobe Photoshop

CATEGORY
Business

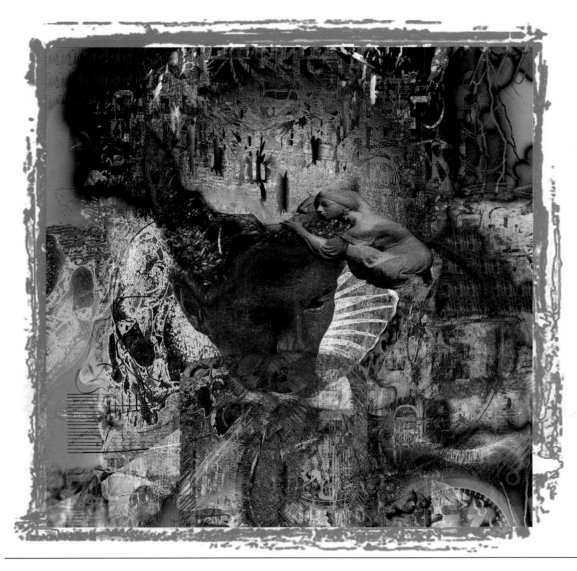

ERIC BERENDT

LIGHTNING

PHOTOGRAPHER
Stock

DIGITAL CREATIVE
Eric Berendt

CLIENT
Promotion

SOFTWARE
Adobe Photoshop,
Adobe Illustrator,
Fractal Design
Painter

CATEGORY
Promotion

Intricate and painterly, this image by Eric Berendt presents a delicate inner cosmology. Seemingly abstract, a long gaze allows faces to emerge and details seem to swim to the surface. It was created as a visual response to music by Philip Glass with inspirational lyrics by Susan Vega. He makes deliberate use of rhythmic elements as he interweaves a symbolic meaning of death and rebirth within the composition.

Besides his own paintings and drawings, Berendt collected public domain photographic and digital images and imported them into Adobe Photoshop. Using an approach akin to an abstract expressionist painter, he collaged, filtered and manipulated visual elements. He then recollaged and many additional filters were utilized. Final adjustments were implemented with color and texture.

The completed piece is a colorful and introspective exploration that transforms the aural into the visual. Music, nature and poetry are often the inspirational starting place for Berendt. With more than twelve years of experience, he integrates the traditional world of art with photography and digital technology. This provides a wealth of possibilities that he uses to create dynamic and soulful design solutions.

KARIN SCHMINKE

EDGE OF THE FOREST

PHOTOGRAPHER
Karin Schminke

DIGITAL CREATIVE
Karin Schminke

CLIENT
Macromedia

SOFTWARE
Macromedia xRes

CATEGORY
Promotion

Focusing on the simplest flora, Karin Schminke brings to life an enchanted Redwood forest. One of the largest graphics software companies, Macromedia, invited her to demonstrate the capabilities of a new software product called XRes. Schminke elected to create fantasy from the familiar. Through an exaggeration of organic elements, a fresh and magical landscape was formed.

Schminke's original photographs of trees and flowers were scanned and imported into Macromedia XRes. Filters were applied to the central image of the Vanilla Leaf flowers to enhance the violet edges of the green leaves and the vibrancy of the flower spikes. The tinted bands of surrounding color were fabricated within the program to restrain the lush flora, while the ghosted trees in the background anchor the piece both visually and conceptual.

Given the dual task of featuring photo-imaging and painting tools available in the software, Schminke's illustration offers a graceful yet sensitive solution. This engaging exploration fits into a larger body of work which focuses on the magic of the natural world.

LOGAN
SEALE

CD & EYE

DIGITAL CREATIVE
Logan Seale

CLIENT
Logan Seale

SOFTWARE
**Adobe Photoshop,
Kais Convolver,**

CATEGORY
Promotion

Logan Seale's commitment to the creative process allows him to transform the mundane into the marvelous. As with much of his work, this self-promotional piece emerged out of experimentation. He often starts with a simple question or curiosity. In this instance, Logan scanned a Gold Photo CD to see how the 3D object would be translated visually. This base image provided some surprising aspects that were interpreted and enhanced. The result is an abstraction of the literal — where meaning and design blend gracefully.

A scan of the CD was imported into Adobe Photoshop and then broken into layers. Working in Kais Convolver, fillers were applied to each layer. The image of the eye was culled from a CD of Seale's earlier photographic work and the final composition was arranged in Adobe Photoshop, using filters and a warm color palette. Through fragmentation and varying opacity, the ones and zeros of digital data become an active formal element; this suggests the connection between codes, language and visual communication. With more than ten years of experience, Logan's approach affords him the opportunity to bring a unique and effective point of view to each project.

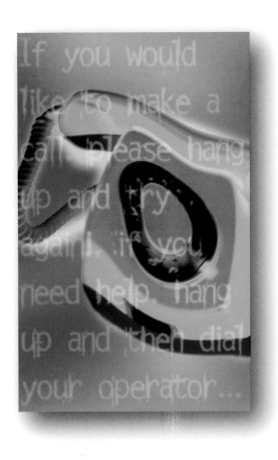

PLEASE HANG UP

PHOTOGRAPHER
Caesar Lima

DIGITAL CREATIVE
Caesar Lima

CLIENT
Promotion

SOFTWARE
Adobe Photoshop,
Adobe Illustrator

CATEGORY
Promotion

MAN TALK

DIGITAL CREATIVE
Rob Magiera

CLIENT
Self Promotion

SOFTWARE
Adobe Photoshop, Adobe
Illustrator

CATEGORY
Promotion

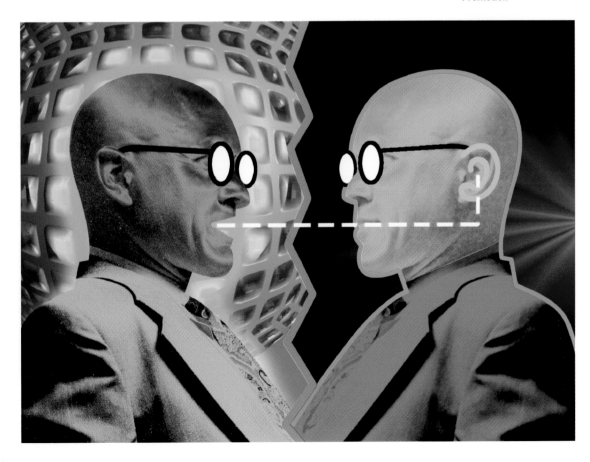

promotional

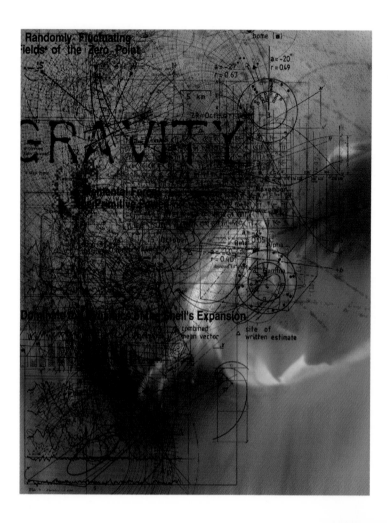

GRAVITY

ILLUSTRATOR
Jeff Brice

SOFTWARE
Adobe Photoshop

CATEGORY
Promotion

MAXIMUM RIGHTS MASK

ILLUSTRATOR
Jeff Brice

CLIENT
Jeff Brice

SOFTWARE
**Adobe Photoshop,
Specular Collage**

CATEGORY
Promotion

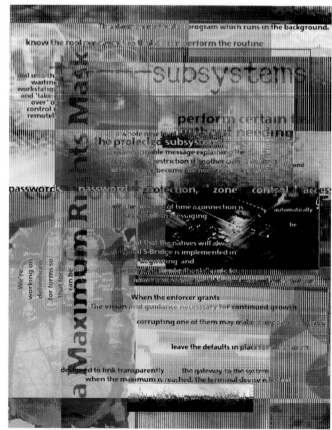

promotional

QUEEN OF THE NILE

PHOTOGRAPHER
Stock

DIGITAL CREATIVE
Eric Berendt

CLIENT
Promotion

SOFTWARE
Adobe Photoshop

CATEGORY
Promotion

UFO

PHOTOGRAPHER
Jeff Brice

DIGITAL CREATIVE
Jeff Brice

CLIENT
Jeff Brice

SOFTWARE
Adobe Photoshop, Specular
Collage

CATEGORY
Promotion

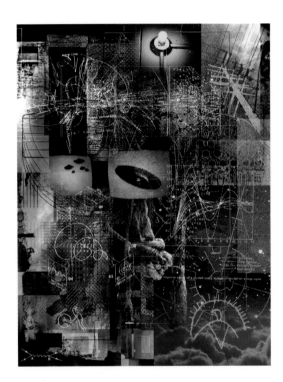

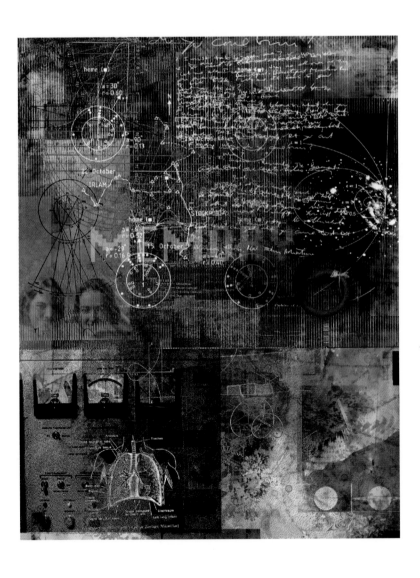

MEMORY

ILLUSTRATOR
Jeff Brice

SOFTWARE
Adobe Photoshop, Specular
Collage

CATEGORY
Promotion

KEYBOARD PUZZLE

PHOTOGRAPHER
Tom Collicott

DIGITAL CREATIVE
Tom Collicott

CLIENT
Tom Collicott Photography

SOFTWARE
Adobe Photoshop

CATEGORY
Promotion

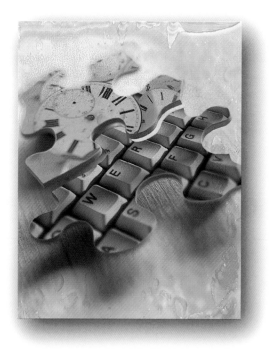

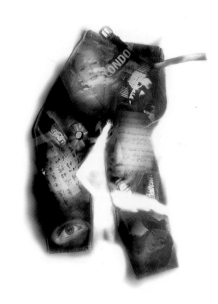

PANTS

PHOTOGRAPHER
Ken Davies

DIGITAL CREATIVE
Ken Davies

CLIENT
Ken Davies

SOFTWARE
Adobe Photoshop

CATEGORY
Promotion

GEARS

PHOTOGRAPHER
Tom Collicott

DIGITAL CREATIVE
Tom Collicott

CLIENT
Tom Collicott
Photography

SOFTWARE
Adobe Photoshop

CATEGORY
Promotion

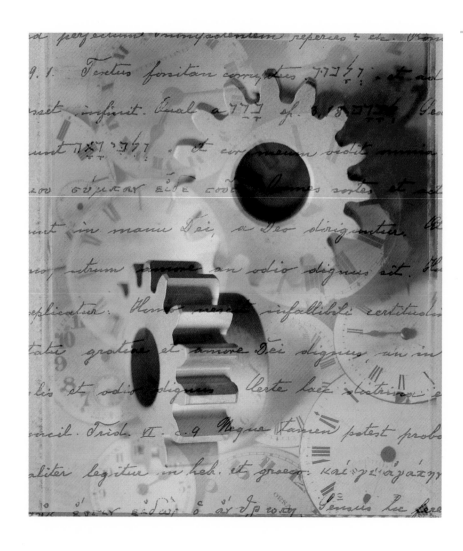

promotional

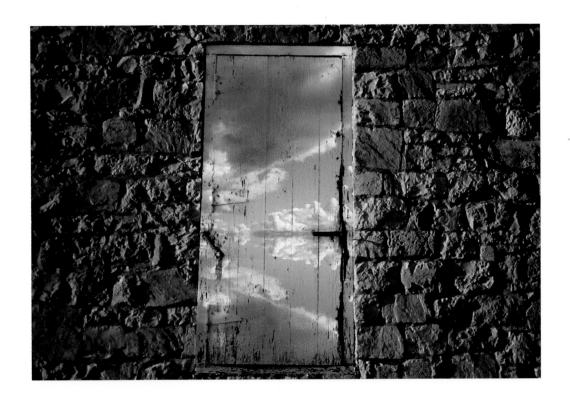

CLOUDY DOOR

PHOTOGRAPHER
Rick Dunn

DIGITAL CREATIVE
Rick Dunn

CLIENT
Rick Dunn

SOFTWARE
Adobe Photoshop

CATEGORY
Promotion

FLOATING LIPS

PHOTOGRAPHERS
Sharon White/Bob Packert

DIGITAL CREATIVES
Sharon White/Bob
Packert

CLIENT
White/Packert

SOFTWARE
Adobe Photoshop

CATEGORY
Promotion

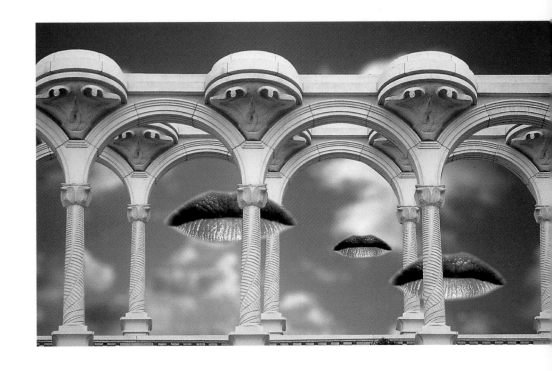

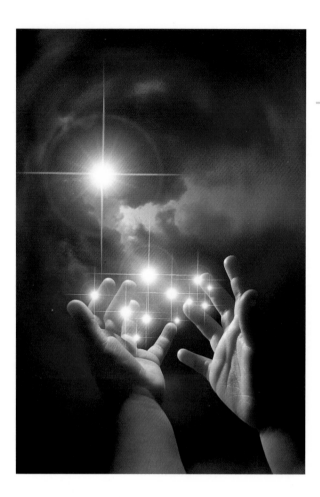

OUR CHILDREN'S LEGACY

PHOTOGRAPHER
Steven Hunt

DIGITAL CREATIVE
Steven Hunt

CLIENT
Steven Hunt

SOFTWARE
Adobe Photoshop

CATEGORY
Promotion

THANKS

PHOTOGRAPHER
Stock, Henk Dawson

DIGITAL CREATIVE
Henk Dawson

CLIENT
Dawson 3D, Inc.

SOFTWARE
Form Z, Electric Image,
Adobe Photoshop

CATEGORY
Advertising

TAPED GLOBE

PHOTOGRAPHER
Tom Collicott

DIGITAL CREATIVE
Tom Collicott

CLIENT
Tom Collicott Photography

SOFTWARE
Adobe Photoshop

CATEGORY
Promotion

SPEAK

PHOTOGRAPHER
Video

DIGITAL CREATIVE
Dan Marcolina

CLIENT
Marcolina Design, Inc.

SOFTWARE
Video Capture,
Specular Collage

CATEGORY
Promotion

RENAISSANCE

PHOTOGRAPHER
Ronald Dunlap

DIGITAL CREATIVE
Ronald Dunlap

CLIENT
Doglight Studios

SOFTWARE
Adobe Photoshop

CATEGORY
Promotion

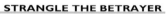

SASSANIAN DREAM

PHOTOGRAPHER
Scott Ferguson

DIGITAL CREATIVE
Scott Ferguson

CLIENT
Studio Promotion

SOFTWARE
Live Picture, Fractal
Design's Painter,
Adobe Illustrator,
Adobe Photoshop

CATEGORY
Promotion

STRANGLE THE BETRAYER

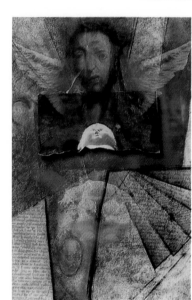

PHOTOGRAPHER
Scott Ferguson

DIGITAL CREATIVE
Scott Ferguson

CLIENT
Studio Promotion

SOFTWARE
Live Picture, Fractal Design's
Painter, Adobe Illustrator,
Adobe Photoshop

CATEGORY
Promotion

LESSON LEARNED

PHOTOGRAPHERS
Joseph Kelter, Mia Park

DIGITAL CREATIVE
BadCat Design, Inc.

CLIENT
BadCat Design, Inc.

SOFTWARE
Specular Collage, Adobe
Photoshop, Fractal
Design's Painter

CATEGORY
Promotion

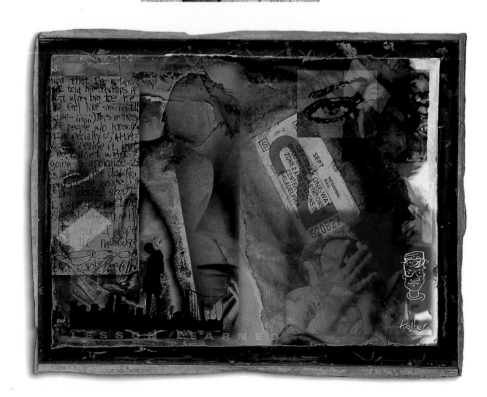

promotional

ANGEL

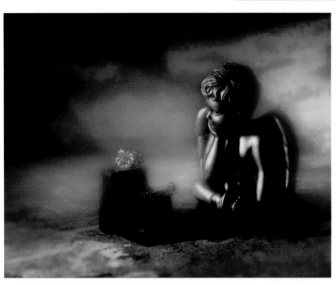

PHOTOGRAPHER
Michael Waine

DIGITAL CREATIVE
Michael Waine

CLIENT
Michael Waine Studio

SOFTWARE
Adobe Photoshop

CATEGORY
Promotion

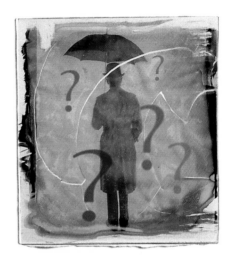

QUESTIONS

PHOTOGRAPHERS
Sharon White/Bob Packert

DIGITAL CREATIVES
Sharon White/Bob Packert

CLIENT
White/Packert

SOFTWARE
Adobe Photoshop, Live Picture

CATEGORY
Promotion

SELTZER

PHOTOGRAPHER
Stan Musilek

DIGITAL CREATIVE
Stan Musilek

CLIENT
Stan Musilek

SOFTWARE
Live Pictures

CATEGORY
Promotion

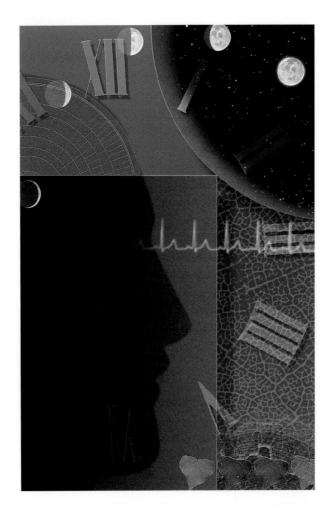

RHYTHMS OF LIFE

PHOTOGRAPHER
Steven Hunt

DIGITAL CREATIVE
Steven Hunt

CLIENT
Steven Hunt

SOFTWARE
Adobe Photoshop

CATEGORY
Promotion

TIME IS CHANGE, TRANSFORMATION, EVOLUTION

PHOTOGRAPHER
Steven Hunt

DIGITAL CREATIVE
Steven Hunt

CLIENT
Steven Hunt

SOFTWARE
Adobe Photoshop

CATEGORY
Promotion

WRENCH

PHOTOGRAPHER
Steven Hunt

DIGITAL CREATIVE
Steven Hunt

CLIENT
Stock Image

SOFTWARE
Adobe Photoshop

CATEGORY
Promotion

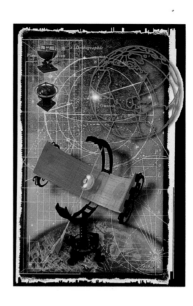

DUALITY & DIVISION

PHOTOGRAPHER
Joseph Kelter, Various Stock
Images

DIGITAL CREATIVE
BadCat Design, Inc.

CLIENT
Specular International

SOFTWARE
Specular Collage, Adobe
Photoshop

CATEGORY
Promotion

NEW WORLDS

PHOTOGRAPHER
Joseph Kelter, Various Stock Images

DIGITAL CREATIVE
BadCat Design, Inc.

CLIENT
Ray Dream, Inc.

SOFTWARE
Ray Dream Designer, Adobe
Photoshop

CATEGORY
Promotion

TRANSFORMATIONS OF MAN

PHOTOGRAPHER
Steven Hunt

DIGITAL CREATIVE
Steven Hunt

CLIENT
Steven Hunt

SOFTWARE
Adobe Photoshop

CATEGORY
Promotion

experimental

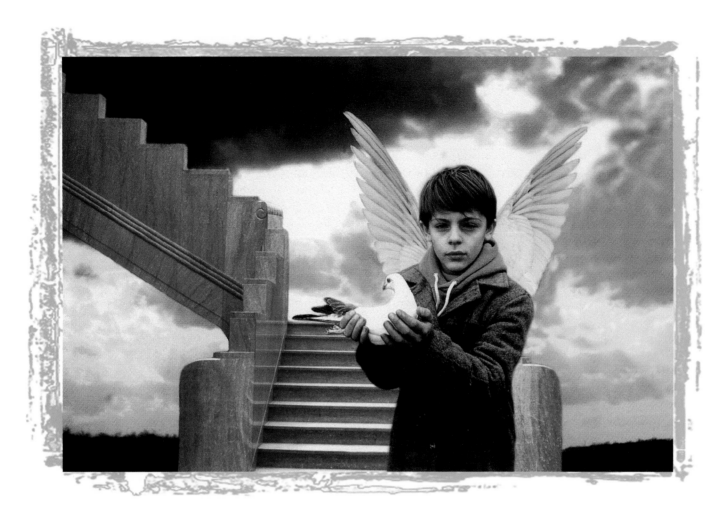

DAVID
CHALK

BOY WITH WINGS

PHOTOGRAPHER
David Chalk

DIGITAL CREATIVE
David Chalk

CLIENT
ChalkMark Graphics

SOFTWARE
Barco Creator

CATEGORY
Experimental

Throughout David Chalk's twenty-five year career, he has allowed his personal and commercial work to evolve simultaneously. This serenely symbolic image began with the discovery of one of his earliest commercial photographs featuring the boy holding a bird. The original photo was commissioned for a children's magazine article about homing pigeons. The mythical quality inspired him to fuse it with his contemporary images.

For this composite Chalk used his Silicon Graphics workstation and Barco Creator software, he started with a dramatic sky background shot in Soviet Central Asia. A section of a staircase from a Travel Holiday Magazine assignment was added to the composition. Chalk then used Creator's warping tool to create a pair of wings from a single image and fit them to the boy's body. The final output was an Iris print on Arches Watercolor paper further enhancing the magical atmosphere.

Working with a simple set of metaphoric signs, the image transforms the average into the sublime. The symbol of the dove and the repetition of the wings on the boy, suggest the sacred nature of the human spirit. This mystical image is the emergence of a new series on Urban Mythology to be produced over the next year. Recognized as a talented photographer, illustrator and animator, Chalk has an immense and diverse visual range which allows him to both emulate and subvert reality.

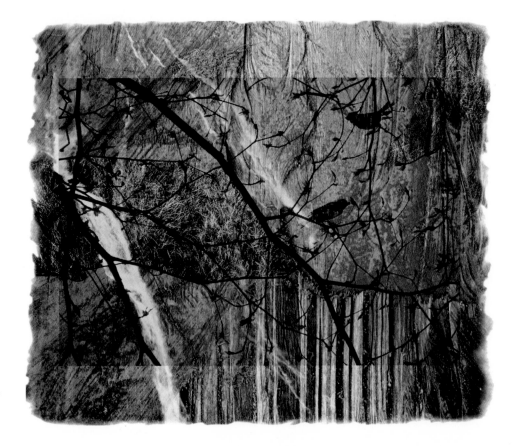

TWO BIRDS

PHOTOGRAPHER
Karin Schminke

DIGITAL CREATIVE
Karin Schminke

CLIENT
Karin Schminke

SOFTWARE
Fractal Design's
Painter, Adobe
Photoshop

CATEGORY
Experimental

SEPTEMBER

PHOTOGRAPHER
Karin Schminke

DIGITAL CREATIVE
Karin Schminke

CLIENT
Karin Schminke

SOFTWARE
Fractal Design's Painter,
Adobe Photoshop

CATEGORY
Experimental

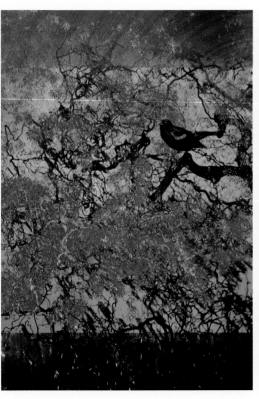

PASSAGE

PHOTOGRAPHER
Karin Schminke

DIGITAL CREATIVE
Karin Schminke

CLIENT
Karin Schminke

SOFTWARE
**Macromedia xRes,
Fractal Design's Painter,
Adobe Photoshop**

CATEGORY
Experimental

MOUNTAIN MEADOW

PHOTOGRAPHER
Karin Schminke

DIGITAL CREATIVE
Karin Schminke

CLIENT
Karin Schminke

SOFTWARE
**Fractal Design's Painter,
Adobe Photoshop**

CATEGORY
Experimental

experimental

NIGHT VISIONS

PHOTOGRAPHER
Karin Schminke

DIGITAL CREATIVE
Karin Schminke

CLIENT
Karin Schminke

SOFTWARE
Fractal Design's
Painter, Adobe
Photoshop

CATEGORY
Experimental

ROOTS/WATER

PHOTOGRAPHER
Karin Schminke

DIGITAL CREATIVE
Karin Schminke

CLIENT
Karin Schminke

SOFTWARE
Fractal Design's
Painter, Adobe
Photoshop

CATEGORY
Experimental

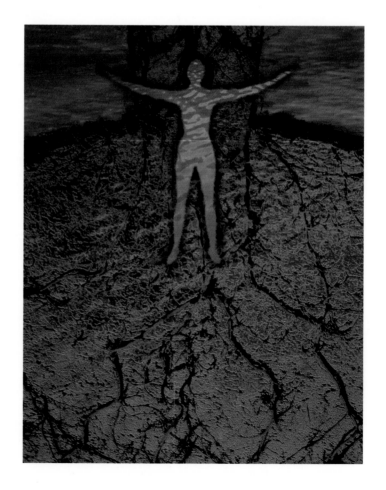

experimental

RYE TWIST

PHOTOGRAPHER
Barry Blackman

DIGITAL CREATIVE
Barry Blackman

CLIENT
Barry Blackman

SOFTWARE
Barco Creator

CATEGORY
Experimental

GEOMETRIC PEOPLE

PHOTOGRAPHER
Richard Duardo

DIGITAL CREATIVE
Tim Alt

CLIENT
Manhattan Transfer

SOFTWARE
Adobe Photoshop,
Macromedia Freehand

CATEGORY
Experimental

experimental

EAST MEETS WEST

PHOTOGRAPHER
David Chalk

DIGITAL CREATIVE
David Chalk

CLIENT
ChalkMark Graphics

SOFTWARE
Adobe Photoshop

CATEGORY
Experimental

ARCHWAY/SKY

PHOTOGRAPHER
David Chalk

DIGITAL CREATIVE
David Chalk

CLIENT
ChalkMark Graphics

SOFTWARE
Adobe Photoshop

CATEGORY
Experimental

ARCHWAY/TRAIN

PHOTOGRAPHER
David Chalk

DIGITAL CREATIVE
David Chalk

CLIENT
ChalkMark Graphics

SOFTWARE
Adobe Photoshop

CATEGORY
Experimental

Experimental *experimental*

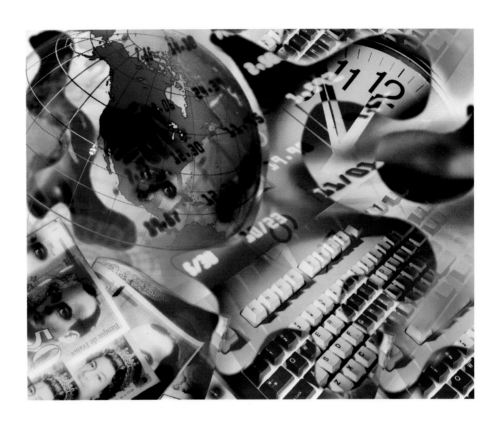

POSNEG ADVENTURE

PHOTOGRAPHER
Logan Seale

DIGITAL CREATIVE
Logan Seale

ART DIRECTOR
**Brian Page/ONeil
Communications**

CLIENT
Digital Equipment Corp.

SOFTWARE
Adobe Photoshop

CATEGORY
Experimental

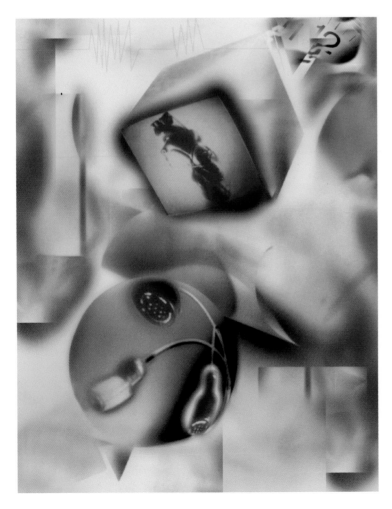

MEDICAL EXPERIMENTS

PHOTOGRAPHER
Logan Seale

DIGITAL CREATIVE
Logan Seale

CLIENT
Bard

SOFTWARE
Adobe Photoshop

CATEGORY
Experimental

experimental

Peacock, Matthew • Anonymous Productions
403 Acorn Street / Lansdale, PA 19446
Phone:215-412-8210 **Fax:**215-393-8132
Email:design@anonymous1.com
Website:http://www.anonymous1.com
22, 66, 94, 95, 150

Romero, Javier • Javier Romero Design Group
24 East 23rd Street / New York, NY 10010
Phone:212-420-0656 **Fax:**212-420-1168
Email:javierr@jrdg.com **Website:**http://www.jrdg.com
22, 24, 93, 125, 140

Schlowsky, Lois & Bob
Schlowsky Digital Photography & Computer Imagery Studios
Representative: Lois Schlowsky
73 Old Road / Weston, MA 02193
Phone:617-899-5110 **Fax:**617-647-1608
Email:Bob@schlowsky.com
Website:http://www.schlowsky.com
41, 47, 60, 61, 64, 66, 67, 130

Schminke, Karin • Woodland Associates
Seattle, WA 98155
Phone:206-402-8606 **Email:**KSchminke@aol.com
153, 168, 169, 170

Schneider, Carl • Carl Schneider Photography
Artist Reps: West:Robert Lawrence 310-838-1704
Midwest/East:Lesley Zahara 800-670-2278
3770 Highland Ave. / Suite 203 / Manhattan Beach, CA 90266
Phone:310-545-9939 / 800-540-6008 **Fax:**310-545-6440
31, 35, 37, 38, 39

Seale, Logan
90 G Street / #4 / Boston, MA 02127
Phone:617-464-0400 **Fax:**617-464-3807
Email:logan@lsphoto.com **Website:**http://www.lsphoto.com
21, 110, 131, 143, 146, 154

Wahlstrom, Richard
Richard Walstrom Photography, Inc.
Artist Representative: Freda Scott
650 Alabama Street / Suite 302 / San Francisco, CA 94119
Phone:415-550-1400 **Fax:**415-282-9133
16, 26, 28, 77, 80

Waine, Michael • Michael Waine Studio
1923 East Franklin Street / Richmond, VA 23223
Phone:804-644-0164 **Fax:**804-644-0166
Email:mw@michaelwaine.com
Website:http://www.michaelwaine.com
10, 25, 27, 29, 163

Watson, Paul • Paul Watson Illustration
225 Sterling Rd. / Suite #9 / Toronto, Ontario M6R 2B2 Canada
Phone:416-535-2648 **Fax:**416-535-2648
Email:watson@passport.ca
65, 69, 72, 73, 139, 144, 145

Whitehurst, William • Whitehurst Studio
256 Fifth Avenue / New York, NY 10001
Phone:212-481-8481 **Fax:**212-481-8962
Email:williw@ix.netcom.com
46, 48, 50, 64, 65, 84, 85, 138, 147

Yang, Eric
213 LaFrance Avenue / #F / Alhambra, CA 91801
Phone:818-284-4727 **Fax:**818-282-5536
Email:etyang@aol.com **Website:**http://www.opticnerve.com
42, 51, 56, 132, 133

DigitalFocus
CALL FOR ENTRIES

DigitalFocus brings the diversity of imagination and provides a detailed examination of how digital and photographic creators have combined their talents to create a new photographic genre. The daring and ingenuity of imagemakers have transformed forever our understanding of the camera and the computer. Forty new visionaries will be selected to showcase their work.

Categories Include:
Advertising, Business, Sports, Editorial, Surreal, People, Media, Promotional and Experimental.

Preparation of Materials
Send slides, transparencies, photographic or laser prints. All work will be returned provided pre-paid packaging is provided.

Deadline
Entries are accepted year round.
Annual Deadline For Submissions November 15.

Please send to:
Nick Greco / DigitalFocus Coordinator
Dimensional Illustrators, Inc.
362 Second Street Pike/Suite 112
Southampton, Pennsylvania 18966 USA
215.953.1415 **Telephone**
215.953.1697 **Fax**
dimension@3DimIllus.com **Email**
http://www.3DimIllus.com **Website**

3Dimensional Awards Annual Website

www.3DimIllus.com

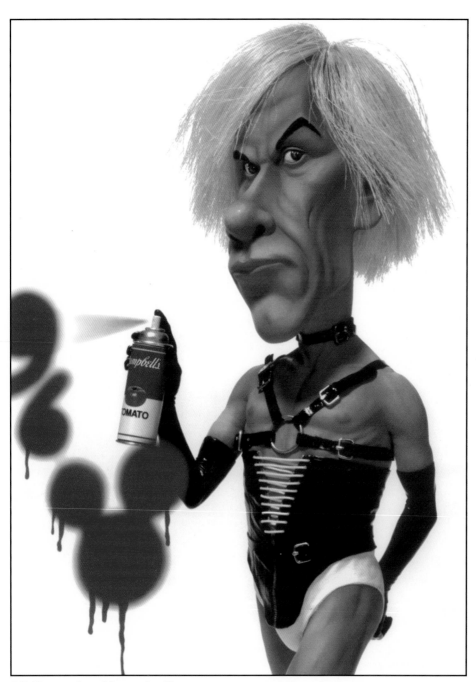

3D Illustration: **Yasutaka Taga**

Expose yourself !

Art directors, art buyers and creative directors ...unleash the captivating power of the third dimension.

This cyber Awards Annual from the 3Dimensional Art Directors and Illustrators Awards Show showcases the Gold, Silver and Bronze winners in the form of ads, brochures, magazine covers, editorials, annual reports, calendars, books, posters, etc.

The 3D Awards Website is an international showcase dedicated to promoting and honoring the best 3Dimensional professionals in the visual communications industry.

Quickly search the 3D Awards Annual Website by Illustrator, Medium or Category to find the source for your next project.

www.3DimIllus.com

Contact Dimensional Illustrators. Inc. at:

362 Second Street Pike / Suite 112 • Southampton, PA 18966 USA
Phone: 215-953-1415 • **Fax:** 215-953-1697 • **Email:** dimension@3DimIllus.com

Website: http://www.3DimIllus.com